Cuba — GOING BACK

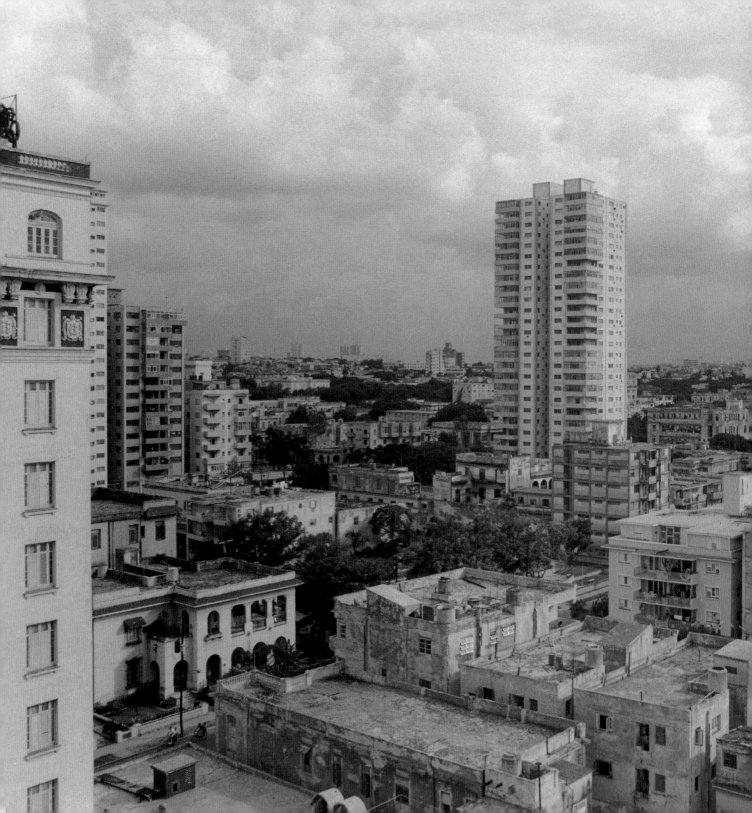

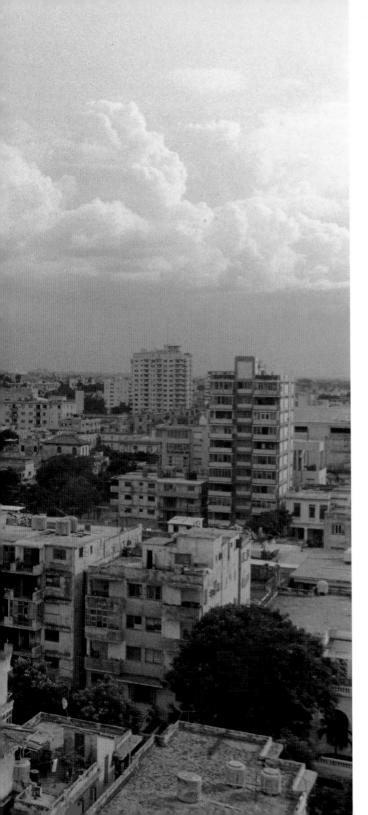

Cuba—
GOING BACK

By TONY MENDOZA

UNIVERSITY OF TEXAS PRESS, *Austin*

LIBRARY OF CONGRESS
CATALOGING-IN-PUBLICATION DATA

Mendoza, Tony, 1941–
 Cuba : going back / by Tony Mendoza. — 1st ed.
 p. cm.
 ISBN 0-292-75232-6 (cloth : alk. paper). —
 ISBN 0-292-75233-4 (pbk. : alk. paper)
 1. Cuba—Description and travel. 2. Cuba—
Pictorial works. 3. Cuba—Social life and customs—
1959– 4. Cuba—Social conditions—1959–
5. Mendoza, Tony, 1941– —Journeys—Cuba.
I. Title.
F1765.3.M46 1999
917.219104′64—dc21 98-51938

For Carmen, who loves all things Cuban
as much as I do.

For my father, who would have been proud
of this book.

For that wonderful institution, the university
sabbatical, which made this book possible.

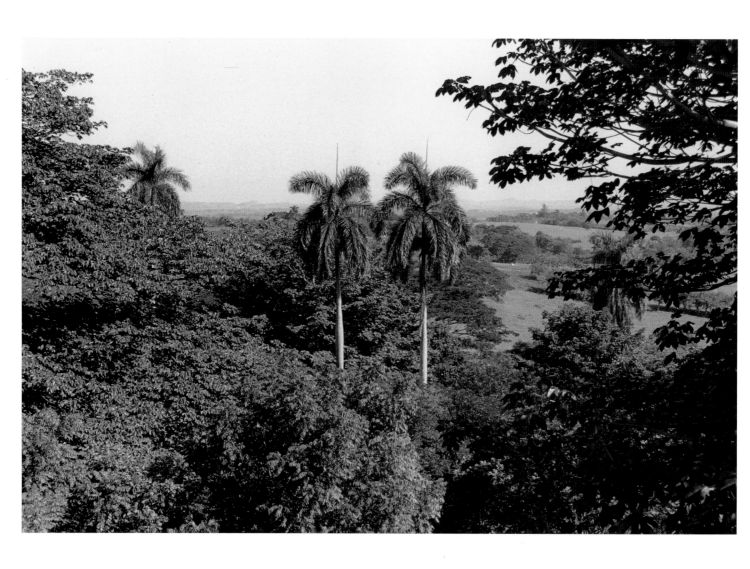

Royal palms in Granma Province

Cuba — GOING BACK

*D*URING THIRTY-SEVEN YEARS OF EXILE
(and thirty-seven years of American winters), I
had increasingly remembered Cuba as paradise.
What I remembered and what I missed was the
weather, ocean, sky, breeze, vegetation, Havana,
Varadero, and the warmth and wit of the Cuban
people. In August 1996 I flew to Havana, my first
trip back, to confirm my memory and to satisfy
my curiosity about life in socialist Cuba.

My family left Cuba during the first wave of
immigration, in the summer of 1960, when Fidel
Castro began the process of nationalizing all pri-
vately owned land, industries, and businesses,
thus making it clear that he intended to create a
socialist state. As I recall, my family was allowed
to take only fifty dollars in cash and the jewelry
my mother wore, while everything left behind
became the property of the state. Many Cubans
left that summer and during the second half of
1960—around sixty thousand. Between 1960 and
1962, two hundred thousand Cubans decided that
socialism was not for them and left the island.

I turned eighteen during the summer of 1960.
I had just graduated from the Choate School, a
private school in Connecticut, and from my some-
what warped adolescent perspective, leaving

Cuba was an excellent move. American girls appealed to me immeasurably more than Cuban girls, who not only didn't drink or neck on dates but also brought along a chaperone. I liked just about everything about American culture, and I was lucky. I went directly from Cuba to a freshman year at Yale, and in 1964 I enrolled at the Harvard Graduate School of Design. By the time I graduated in 1968 with an architectural degree, I was a different person, seduced by Cambridge and the exuberance and open-mindedness of the times: the hippies, the antiwar movement, communal living, pot, acid, Rolfing, Primal Scream. I'm almost embarrassed to admit this, but I still think of the sixties and early seventies as a truly wonderful period, another paradise. I expected an adventure every day.

In 1970 I joined a commune in Sommerville, a working-class community next to Cambridge, with twelve men and women. Our minimal living expenses allowed many of us to drop regular jobs and pursue other interests, mostly in the arts, and we enjoyed ourselves immensely. The year we decided not to have our traditional New Year's bash, seventy-five people still showed up. I lived in the commune throughout the 1970s, and along the way I quit architecture and became an artist/photographer. During all this time, Cuba felt like a distant and not very relevant past.

That started to change when I moved to New York in 1980, hoping to give my art career a boost. The eighties weren't as interesting as the sixties and seventies, so I had more time to think and reminisce. My romantic life also needed a boost. After many failed relationships with American women, I met a Cuban woman with a background very similar to my own—Carmen had studied art history in Boston and was also a veteran of the sixties in the United States. It was the first time in exile that either of us had dated another Cuban, and we were both surprised to feel so attracted, comfortable, and compatible. We moved in together. After speaking mostly English for twenty years, we rediscovered the pleasures of our native language. We purchased an alarming quantity of cassettes and CDs of old Cuban music and danced in our living room to the rhythms of Cuban boleros and *danzones*. Black beans and fried plantains reappeared in our kitchen, and I started wearing a guayabera, the traditional Cuban shirt.

After living in Brooklyn for a few years, we wondered what it would be like to live in a Cuban community, and in the tropics, so we moved to Miami and liked it, with reservations. We missed the museums, the art shows, the endless choice of movies and concerts we had become accustomed to in Boston and New York. We also were not used to living in the same city with a very large group of relatives, many of whom would start conversations by asking: "When are you two going to get married?"

Still, we liked our relatives, we loved the climate, the ocean, the wild parrots in our garden, and our late-afternoon cheese and wine picnics in Key Biscayne—where we eventually got mar-

ried in a ceremony by the sea. We would have stayed in Miami had it not been very difficult for an artist to earn a living there, and, more to the point, we needed health insurance; Carmen had a boy from her first marriage, and we both wanted another child. In 1987 I was offered a job teaching photography at Ohio State University, so our family moved to Columbus. To the tundra.

People born on islands shouldn't move to the Midwest. Every winter I had memories of Cuba that seemed to revolve around the climate. I remembered Varadero Beach, where my entire family on my mother's side spent the three summer months at my grandfather's house. I especially remembered the porch overlooking the ocean. I ate breakfast there every morning, always on the lookout for the large fish—sharks, barracudas, tarpons—that glided close to the surf in the early morning to feed on sardines. After a morning of fishing and waterskiing, I would return to the porch. There was a comfortable, soft couch there, where I stretched out after lunch and napped. I can still feel the sea breeze on my face and hear the hypnotic sounds of the surf. I wanted to see that porch again and go swimming in front of the house.

When I turned fifty my Cuba nostalgia started to get out of hand. I wrote a series of coming-of-age fictional stories about a fourteen-year-old boy called Tony who lived in Havana in 1954. I would listen obsessively to CDs of Lucho Gatica and Rolando Laserie, the singers who were popular on the Cuban radio during the 1950s. Every time

I saw pictures of Havana in photography books shot by European journalists, I would strain to see if I recognized the streets, the parks, the buildings in the background. I remembered Havana as an exceptionally beautiful city, but in my youth I had been unconcerned with beauty and had no frame of reference. Now I knew better, and I wanted to see Havana again. I especially wanted to see the house where I grew up and the huge mango trees in the garden, where I must have killed a thousand sparrows with my BB gun (which I regret now!).

In 1996 I asked the university for a sabbatical. In my academic position I'm expected to do research, so I proposed to go to Cuba, take pictures, and keep a diary. The United States allows Cuban exiles to return to visit relatives, for a maximum stay of twenty-one days. I found one distant relative still in Cuba and proposed to visit her. The Cuban government is more than happy to grant visas to visiting exiles—Cuba needs their dollars. In late August I flew to Miami and then boarded the Peruvian charter that flew us to Nassau and from there to Havana.

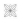

THE FLIGHT WAS SCHEDULED TO LEAVE at nine in the morning, but they asked us to be in the airport by five o'clock. I could see why. The plane was full, and everyone, except me, was bringing four or five huge bundles of supplies for relatives—food, medical supplies, clothes,

shoes, toys. Cocoons, they called them, because a Nicaraguan with a portable machine, for three dollars a wrap, was kept busy wrapping many layers of cellophane around the suitcases and bundles. According to the veterans of this trip, the cocoons prevented the Cuban workers and officials at the José Martí airport from stealing everything.

On the plane the passengers milled around in a festive mood, told jokes, and exchanged stories about the current situation in Cuba. A group in the back had gathered around a man with a guitar and sang old Cuban songs throughout the trip. The elderly woman who sat next to me told me she goes back every summer—U.S. regulations allow Cuban Americans to visit their relatives once a year. "I can't help it," she said. "I feel excited every time I go back. Havana brings back so many memories." She was going back to see her sisters. When I asked about her family in Cuba, she kept saying: *"Me dan tanta pena, los pobrecitos."* (I feel so sorry for them, the poor dears.) She was bringing five fifty-pound bundles full of supplies. She also said, fiercely: "If the Cuban customs officer says something to you about your documentation being incomplete, don't believe him and don't pay him a thing. Tell him you'll call his superior."

I had no trouble at the Havana airport, although the customs official pointed out that my passport, which I had renewed recently, wasn't signed. I quickly pulled out a pen and signed it. I might have detected a certain look of displeasure

on the official's face, but he let me through. Then I encountered the first example of the shortcomings of socialism. I went to the men's room, where a worker sat on a chair and for one peso gave me two sheets of toilet paper, four inches by four inches.

"You must be kidding!" I said. Apparently, I had to pay more for more sheets.

Every public toilet, including the one at the best-known hotel, the Habana Libre, has an employee dispensing toilet paper inside—either a telltale sign of socialist inefficiency or, more likely, an acknowledgment of the fact that if they put the toilet paper inside the toilet stall, it would be stolen.

A friend of my wife's family picked me up. I'll call him Mario. My wife was raised in La Esperanza, a small town in Las Villas province, now called Villa Clara. (The revolution changed everything, including the number and the names of the provinces. What used to be Oriente Province is now divided into four new provinces, including Granma Province, named after Castro's boat.) In the car Mario told me some wonderful stories about my wife's mother, a legendary beauty in La Esperanza during the old days, and had only horrible things to say about the current state of Cuban socialism, although, like most Cubans I met, he once supported the government and in the seventies went abroad on internationalist missions. He lives well—not on his retirement income, but by renting two bedrooms in his three-bedroom apartment to tourists. All his bedrooms

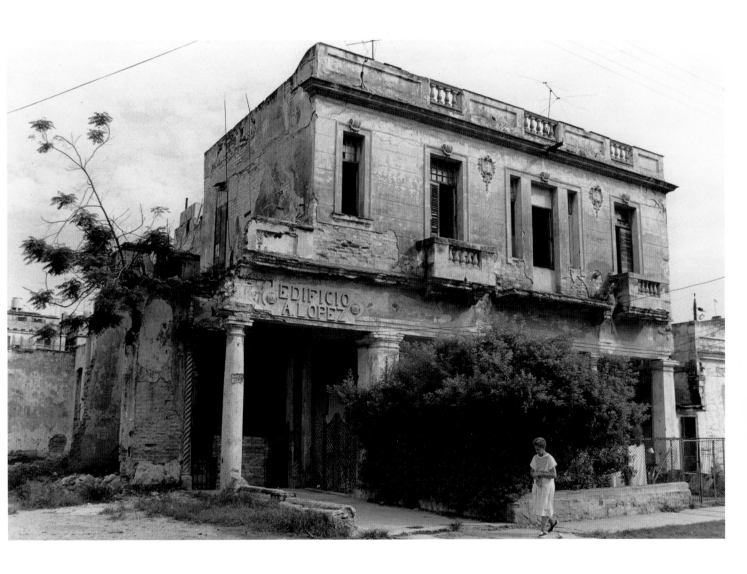

The López Building in Havana's
El Vedado neighborhood

American cars, dating from the thirties, forties,
and fifties, parked by an apartment in El Vedado

were already rented to Italian tourists, but he had arranged for me to rent another place, an apartment in El Vedado, for twenty-five dollars a day. It had a small kitchen, air conditioning, and a black-and-white TV. Apartments like this can be found everywhere in Havana, where an income of twenty-five dollars a day amounts to a small fortune. Most families will very gladly rent you their apartment, move out, and stay with relatives.

Passengers on the flight had warned me that I was going to find a ruined Havana, but I was still surprised during the drive from the airport. Havana reminded me of the set for the movie *Brazil;* the same old factories that lined the airport road during the fifties were still there, rusting away in the tropical sun, and still in use. I could see people on bicycles everywhere, like an old newsreel of an Asian country. We drove by 1950-model cars, 1940-model cars—we were in a time warp. Then we entered the residential area where I used to live, El Vedado, an affluent neighborhood in pre-Castro days. The wonderful gardens I remembered were now wildly overgrown or barren, and the buildings were even more depressing. Havana's architecture is pseudo-Greek and -Roman, and after thirty-seven years of socialism, the buildings appeared to be exact copies of the ruined monuments I saw in Greece and Rome. Instant antiquity! The damage seems more serious than the need for paint and new windows, which most buildings need. What holds the buildings up—the concrete, the structure—seems to be chipping away, as if a new breed of concrete-eating vermin were loose in Havana. In 1960 the revolutionary government came up with the Urban Reform Law, wherein the ownership of most houses and apartments was passed on to the dwellers, who paid for the units in low monthly installments. The new owners did not suspect that they would never again have the funds, nor the materials, to maintain their homes.

The apartment Mario rented for me was half a block off G Street, also known in the old days as the Avenue of the Presidents. Coincidentally, Mario's apartment was on G Street, and my family's former house was also on this avenue. I asked Mario to drive by it—I just wanted to get out and take a quick look. I almost couldn't believe what I saw: the house looked exactly like the house I had left thirty-six years before. It had been perfectly maintained; nothing seemed out of place. As I looked in from the iron gates, I felt like an actor in one of those *Back to the Future* movies, returning to the life I lived during the fifties. All that was missing was the voice of my grandfather joking and laughing while he played dominoes with his friends on the side porch.

The other five houses on our block hadn't fared as well. They looked as if they had been bombed. The building next to our house, a Jewish synagogue in the fifties, was in ruins. The house on the corner, where I used to play with a boy my age, was crumbling. The other three houses on the block were standing, but in very sad shape. I was to see this throughout Havana: most dwell-

House in Havana, at 23rd and G Streets,
on the corner of the block where I used to live

House in El Vedado

ings, where the Cuban people live, are dilapidated, but suddenly you see a house in perfect condition. This invariably means that it's a government house—a party headquarters, a ministry, the headquarters of a mass organization. My family's former house is now a government function house. All they do there is give dinner parties.

A similar situation occurs with the cars in Havana. The majority of cars owned by Cubans, mostly 1950s American cars, are in terrible shape. You also see many Russian Ladas, dating from the 1970s and early 1980s, which were given as rewards to model workers or party militants. I was told that Ladas break down more than the older American cars. Then you see brand-new Italian Fiats in perfect condition. Whenever you see a brand-new Fiat, it belongs to a government agency or a government official. Socialist equality is at work in Cuba, but on two different levels.

After I dropped my bags, Mario invited me to his apartment for a drink. He lives on the eighth floor of a once elegant apartment building overlooking the ocean at the base of G Street. Going up in the elevator was my second experience of the shortcomings of daily life in Havana. The lights on the elevator were out. The door closed and we went up in total darkness. I was nervous going up in that pitch-black, slow, and incredibly creaky elevator—which, apparently, Otis Elevator hadn't serviced since 1960—and in a city with a reputation for sudden blackouts.

Over drinks, I asked Mario why they didn't fix the light.

"The manager of this building earns a miserable wage from the government. He won't fix anything unless we give him some money. Nobody minds the dark elevator that much; you get used to it."

"What happens if you're in the elevator and there's a blackout?"

"No problem. You can open the door by hand, and if you get caught between floors, you can go out through the roof."

That was reassuring.

Mario had three young Italian men staying in his apartment. They weren't in, but he said they were very polite fellows. They worked in the same office in Rome and had come to Cuba on a sex junket.

"Do they bring the *jineteras* to the apartment?" *Jineteras* is the new Cuban word for prostitutes.

"Of course. I don't interfere with the guests' private life. I'm not a moralist. Besides, the girls they bring here are very polite. They're educated. They are not like the hookers you have in the U.S. The men who stay here are regulars. They come back every year. I'm booked solid every summer. I make them a good breakfast, and my bedrooms have a great view of the ocean. We usually rent two bedrooms at twenty dollars a day per bedroom, but now we have all three rented. My wife moves out and stays with our daughter. I sleep on the porch. It's inconvenient, but here there is no tomorrow. If you can rent three today, you rent three today. Tomorrow the government will pass a law making this illegal."

(Mario was right. In July 1997, the government slapped restrictions and extremely stiff taxes on the practice of renting private rooms to foreign tourists.)

When I left, I told him his elevator scared me and I was going to walk down.

"Nonsense," Mario said. "I'll go with you."

So I went down in the elevator from hell. There was a new twist. Just about everyone in Cuba smokes. Mario is a chain smoker, and he smoked on the ride down. He didn't even ask for permission. I'm an ex-smoker, and I'm horrified by smokers and cigarette smoke. Still, I was thankful for that little glow.

✳

I MOVED INTO MY APARTMENT AND WENT to work. I had twenty-one days to walk up and down every city street, revisit the places I remembered, take pictures, do video, and talk to people. In those twenty-one days I shot eighty rolls of film and talked long enough to get to the topic of politics with more than two hundred persons. I kept a diary and wrote down every night what I had heard during the day. I taped as many conversations as I could, but Cubans seemed uncomfortable when I pulled out my small tape recorder. They would stare at it and say: "I would prefer it if we talked without that tape recorder." Otherwise, people expressed their opinions freely, especially when it became clear that I was an exile and not a government undercover agent.

On the first day I was walking around and taking pictures in my old neighborhood in El Vedado. A man in his twenties crossed the street to talk to me.

"Amigo, where are you from?"

"I'm from here," I said.

"Naw. No way. You're not from here."

"Why not?" I protested.

"Because Cubans don't look like you, don't dress like you, don't carry Nikons like you, and don't speak like you."

The last item in the list really bothered me. I always thought I spoke perfect Cuban Spanish. After all, I left when I was eighteen, but I soon realized that in the thirty-six years I'd been away the language had changed. Cubans seem to speak faster now, and the intonation is different. Havana is now a predominantly Black city, so slang and idioms from Black culture predominate. The political situation has also created many new words, and everyone speaks eloquently, possibly due to the influence of Fidel, who seems to give a speech every day and is a genius with language. (I became accustomed to calling Castro by his first name, as most Cubans do, as a sign of familiarity rather than approval. Only the most militantly anti-Castro Cubans, in both Cuba and Miami, refuse to refer to him as Fidel.)

Eventually I convinced this man I was an exile, back for a family visit. The reaction I got was not what I expected:

"You were lucky to get out. How could you be so smart to leave this place in 1960?"

House in El Vedado

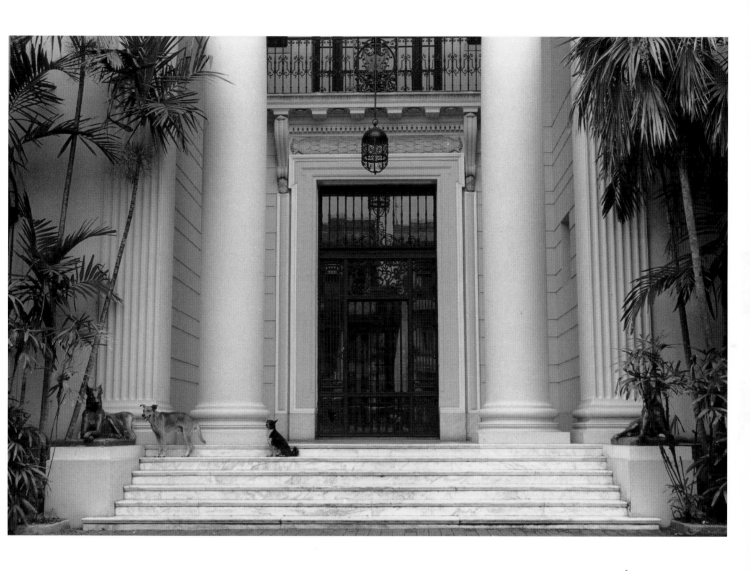

Government house in El Vedado

I expected to find anti-American opinions in Havana, since Fidel has been attacking the United States in speeches for thirty-seven years, but what I found was exactly the opposite. When I told Cubans that I was from the United States I always got warm and positive reactions. The most coveted T-shirts in Havana are Chicago Bulls or New York Yankees T-shirts—anything with an American institution printed on it. At the end of the first day I was photographing in Cayo Hueso, a rough neighborhood in the Old City, when two young men spotted me and suddenly ran toward me. I had been warned to be careful in the Old City because tourists were being robbed, so I was a bit nervous.

One of the men said, "Hey! Are you an American?"

"Yes," I said, cautiously.

"Hey! Why doesn't the U.S. invade? This is shit. Why doesn't the U.S. invade?"

I realized early on that I needed to talk to other Cubans besides those I met on the street while photographing during the day. I was concerned that the people who approached me would be those who wanted to meet tourists to get something from them and thus more likely to express antigovernment opinions, especially to a Cuban exile on a family visit. As it happened, I met a different group of Cubans in a wonderful place close to my apartment, a *paladar,* or family restaurant. The grandmother was the chief cook, her sons her assistants, and her grandchildren waited on the tables. Not only was the food excellent and affordable (\$5 for a generous serving of roast pork, fried plantains, *yuca* (cassava), black beans, and rice), but I realized it was a great place to talk to the other customers—a much more prosperous group of Cubans than the ones I met on the streets. Most were professionals: architects, economists, artists, athletes, and, of course, tourists and *jineteras.* I ate there every night.

I'm an ex-architect; I ended up calling and meeting a group of architects whose phone numbers were given to me by architects in Miami. To round out my research, I tried to watch the news every night to get a feeling for the information that a state-controlled broadcasting system imparts on the public. Finally, on my return, I found a Web site with every speech ever made by Fidel Castro. I printed them out and read most of them.

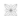

If I were asked at this time how I see the Revolution, I would say that I view it as a train that has already started and achieved great speed [applause], a train fully under way, a train at full speed. . . . At any rate, the train of the Revolution lost its reverse gear on the first day. It cannot reverse or make U-turns, and it has no brakes. [applause].

—FIDEL CASTRO, FEBRUARY 2, 1965[†]

[†] Excerpts from Castro's speeches were taken from the *Latin American Network Information Center (LANIC), Castro Speech Databases* (http://www.lanic.utexas.edu/la/cb/cuba/castro.html).

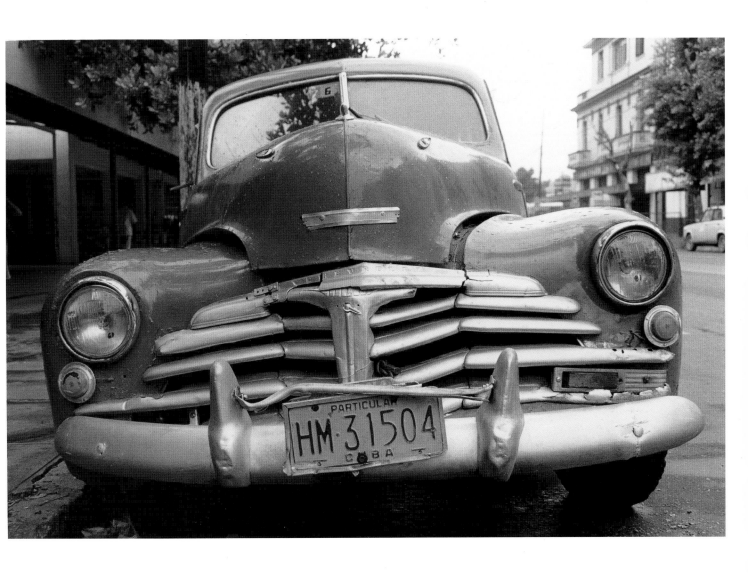

Car in Havana

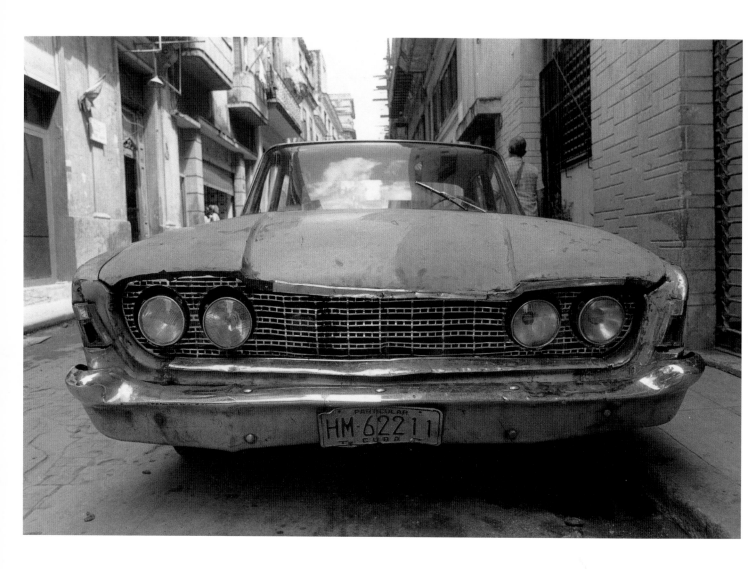

Car in Havana

Car in Havana

The train metaphor that Fidel used more than thirty years ago is still applicable. All along he has stressed that socialism is irreversible, and now that times are particularly difficult because of the loss of Soviet subsidies, he stresses this fundamental position even more frequently. From the early 1960s until the fall of the Soviet Union, Fidel's standard ending for every speech had been "Fatherland or Death, we will win!"; since then, it has been "*Socialism* or Death, we will win!" The message to the Cuban people is clear: saving socialism is the main concern of the Cuban government.

Nevertheless, the overriding message I got from my conversations with Cuban citizens is that very few people seemed happy with socialism, with the revolution, or with Fidel. Of the two hundred people I spoke to in some depth, five wholeheartedly supported the revolution, maybe five supported some of it but were very unhappy with the economic difficulties brought on by the fall of the Soviet Union, and the rest didn't seem to have one good thing to say about Fidel, socialism, or the current state of affairs in Cuba. I found it interesting that among older people almost everyone stated that at one time they supported the revolution, but thirty-seven years of hardships was enough. They wanted change, but they also seemed resigned. I heard this expression often: *Esto está de madre, pero no hay quien lo tumbe.* This is terrible, but there's no one to overthrow it. The overwhelmingly common feeling among Cubans, expressed by virtually everyone, is that as long as Fidel is around, nothing will change.

The main reason for the dissatisfaction I found is clear. While issues dealing with the absence of the most basic freedoms came up often in conversations, the problem that continually grates on people is more fundamental: it's not possible to eat two meals a day for one month with the monthly salary the state pays. There is food available, partly due to the Free Agricultural Markets, an economic reform grudgingly instituted in September 1994, but state employees, who make up a large majority of Cuban workers, don't make enough money to buy there.

The average salary in Cuba is 160 pesos a month. The workers I met at the docks get paid the minimum monthly salary, which is 108 pesos; highly accomplished professionals, such as brain surgeons, make the highest official salary, 400 pesos. This 4:1 salary ratio has been fairly constant through the history of Cuban socialism, fulfilling the goal of equality that has been one of the central tenets of the revolution. The problem Cubans face is obvious when you translate these salaries to dollars. The black market rate of exchange, where one finds the best deal, was 20 pesos to a dollar when I was there, in September 1996. (That rate continues to hold as I complete this writing, in December 1997.) This means that the average salary in Cuba is eight dollars a month. The translation of the peso salaries into dollars is crucial because after the legalization of the dollar in 1993, the dollar became the dominant currency in Cuba. Virtually any object or food item can be acquired with dollars in the

Peso store in Havana with nothing to sell

thriving black market, in the official dollar stores, and at the *paladares*, while the shelves of the peso stores are woefully empty.

The peso stores are where Cubans get their monthly supplies of food, using the notorious *Libreta,* the ration book. With rationing comes the unending annoyance of having to spend a large portion of every day waiting in the food line, as well as always being short of crucial items that never materialize, like cooking oil. Food has been rationed in Cuba since 1962. Even during the heyday of Russian subsidies, in the early eighties, there was never enough food, making rationing necessary. The fall of the socialist bloc, the end of Soviet subsidies, the ensuing downward spiral of the Cuban economy—all have contributed to a critical shortage of food. Most people told me that the monthly amount of rationed food lasted until the second or third week. I took photos inside many *Libreta* stores, and all the pictures show barren shelves.

I looked at many ration books: Cubans were getting a monthly ration of five pounds of rice, three pounds of beans, five eggs, one chicken, half a pound of coffee, milk for children up to age seven, one bar of soap, two rolls of toilet paper, three packs of cigarettes. I saw no pork (which in my youth was the traditional Cuban meat dish), nor fish, nor garlic, nor cooking oil— although if I flipped the book back three or four months, a pound of fish and a bottle of cooking oil would make an occasional appearance. On the plus side, the prices of the available rationed items are low and have generally amounted to 40%–50% of the average monthly salary of 160 pesos. With the remaining 80 pesos, a Cuban has to pay around 15 pesos for the electric bill, 6 pesos for cooking gas, 5 pesos for water and sewer, and maybe 15–20 pesos if he or she is still paying for an apartment (although most people have finished paying their installments and own their dwellings).

With whatever money is left, Cubans have to supplement their diet by buying at the Farmers' Market. In the large and busy Farmers' Market at 19th and B Streets in El Vedado, every conceivable food item is available, but expensive. A pound of pork costs thirty pesos, a pound of rice costs eight pesos, and avocados are three pesos each. If we assume that the average Cuban worker has forty pesos left after paying for his rationed food, rent, and utilities, he or she will have enough to buy only one pound of pork, one pound of rice, and one avocado. And for the sake of simplicity, I haven't included purchases of clothing, shoes, or toys, all of which have disappeared from the ration books in recent years. Not to mention any manufactured product, like a radio or TV or—dare we even mention it?—a car. At eight dollars a month, the average Cuban would have to save his or her entire salary for a hundred years to buy a car.

Since it's obvious that Cubans cannot make it on their official salaries (and I didn't see any obvious signs of malnutrition among Cuban citizens), how do people survive? It's simple. Every-

one has to *resolver*. To solve. It's one of the most commonly heard words in Havana. How are you? *Aquí, resolviendo. La búsqueda* is another word one hears. The search. Another common phrase is *Hay que inventársela*. One has to invent it. All these terms refer to the many creative and mostly illegal ways to make ends meet, so common that they are a part of the system. Most Cubans do a lot of *resolviendo* at their place of work. If a Cuban is offered a job in a ministry, he or she needs to know the potential for *la búsqueda* at that job. Hopefully, the job has a product that gets distributed, and some of that product can get diverted and distributed among the workers and managers. After all, the government never tires of reminding everyone that in Cuba everything belongs to the people.

Construction outfits solve many problems for the workers. Lumber, concrete blocks, and steel rebars can be sold easily in the black market. Food distribution outfits are even better. The family diet will improve spectacularly if you are employed in a food warehouse. At a gas station, gasoline can easily get siphoned from the tanks, without going through the meter, and be sold privately. When I rented a private taxi to take me around the countryside in Granma Province, the driver never bought gasoline at the gas station. In every town he knew someone who brought out the gas in a metal canister from the back of his house. Everybody is so busy doing *biznes* that Cuba is probably the most capitalistic and entrepreneurial country in the world. A crude word for all this illicit economic activity is *stealing*, but Cubans don't use that word. There is a joke that socialism has only two fundamental problems: lunch and dinner. The official salaries don't solve those two problems. *Hay que resolver.*

I got a good feel for the number of goods being diverted from state enterprises by living in a large apartment building. When I was home at night, the doorbell rang often. I would answer. "Would you like to buy some toilet paper, some avocados, lobsters, rum, cigars, cooking oil?" All of it was stolen.

How is the Cuban government reacting to all this illicit activity? By passing stiffer and stiffer sentences for economic crimes. In July 1997 a new round of stiffer penalties was passed, including jail terms of up to twenty years for pilfering and waste of state property.

The moment I understood the dismal financial situation Cubans face, and what they have to do to solve their problems, I started asking everyone I met why the government didn't pay more. Was the government simply being malevolent, paying a slave wage to the entire nation, while at the same time endlessly professing the official philosophy, which I saw enlarged on walls and billboards everywhere? *Everything we do is for the benefit of the Fatherland, everything we do is for the benefit of the people.* Obviously, I thought, the government must have an income from the sale of sugar, cigars, and nickel, and there had to be a significant income from the tourists that I saw everywhere in Havana. I brought $2,000 to

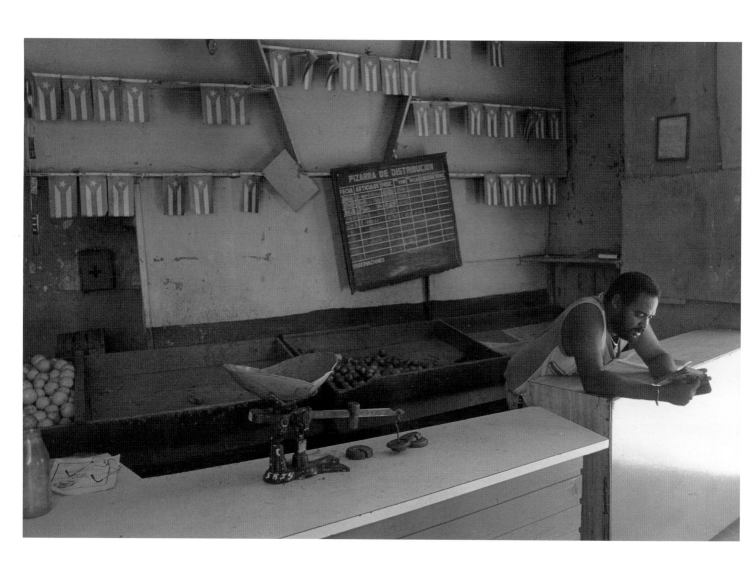

Libreta *(ration book) store with*
very few food items available

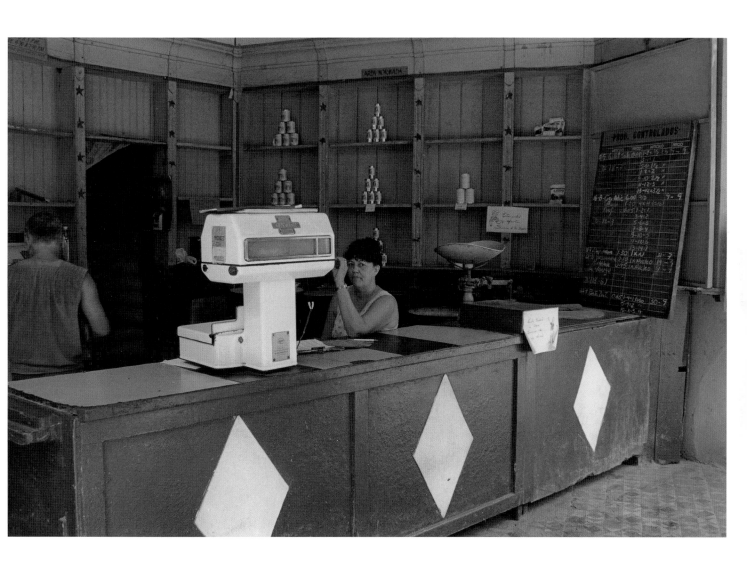

Libreta store with few items to sell

Cuba and spent it all. Surely the government has an income, and it didn't seem to have high expenses, at least labor expenses, which in most countries is the brunt of the expenses of any enterprise. The revolution can be seen as a giant corporation, and it has a highly educated labor force—an entire island—working for eight dollars a month. Government enterprises must be making a huge profit, unless they're being run by unbelievably incompetent managers or blatant crooks. So where is the money going?

I first asked Mario, the retired doctor.

"There is no money! There is no production!" he shouted, shocked by my ignorance. "The inefficiency of this system is monumental! Tony, you have to understand, first of all, that tourism doesn't produce! A fortune has been spent on tourism, but the tourism that comes to Cuba is package tourism, the cheapest tourism. The hotels that have been built are luxury hotels, they have cost a fortune, and mostly they are empty. Many tourists stay in apartments. Nothing is being produced here. Sugar is not producing any money because no one wants to cut cane. It's a horrible job and it doesn't pay. Who is going to work like an animal for ten dollars a month? The volunteers that we used to have, brigades from the cities that went to the country to cut cane for free, we don't have those anymore. Why? Because the revolutionary spirit that was alive here at one time is now dead. Because the government doesn't have the Ladas and the refrigerators that they used to get from Russia to give to the militants and the model workers. Nothing gets produced because nobody works. It's very simple. Besides, the government pays in pesos, and pesos are useless. You can't buy anything with pesos. Go to a peso store and you will see empty shelves. The huge problem we have in Cuba is that food is not being produced and we don't have the money to import it."

"But," I observed, "when I go to the dollar stores I see plenty of food."

"Yes, you can find anything in the dollar stores, but the prices are so high that only a small minority of Cubans can shop there. A normal meal, bought in the dollar stores, will cost a monthly salary."

"Still," I said, "there are other industries. Fishing, nickel. Look, the government has to have an income because the soldiers from the Interior Ministry ride in late-model trucks, and I see many new tourist hotels in Havana. There has to be money because money is being spent."

"What you have to understand, Tony, is that this is a very repressive system! You are going to see it. There are 75,000 plainclothes spies in the streets, and we have the largest army in Latin America. To maintain a repressive system like this one costs money. That is the main priority. Whatever is left is going to build the new hotels, which will continue to be mostly empty. Why would a western family want to bring their kids to a Stalinist state? You have to understand this about Cuba. Before tourism, money was spent on sugar. Billions of dollars in Soviet aid. And the sugar

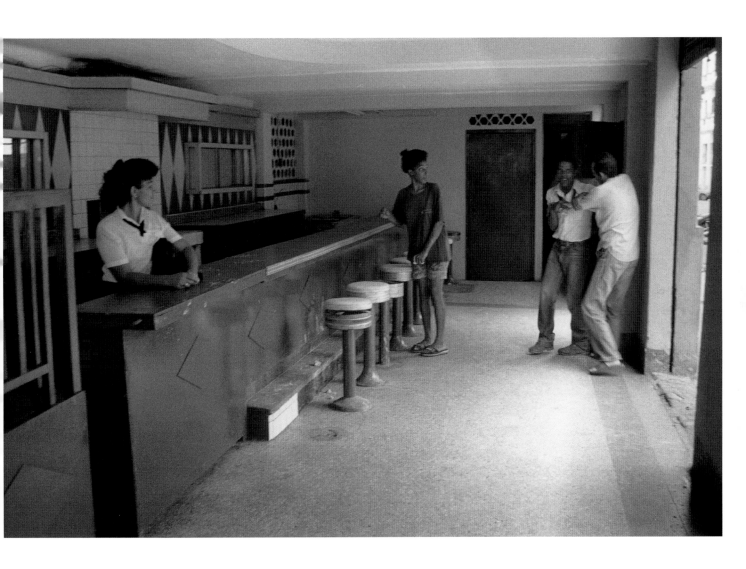

Two men fighting in a bar in Havana

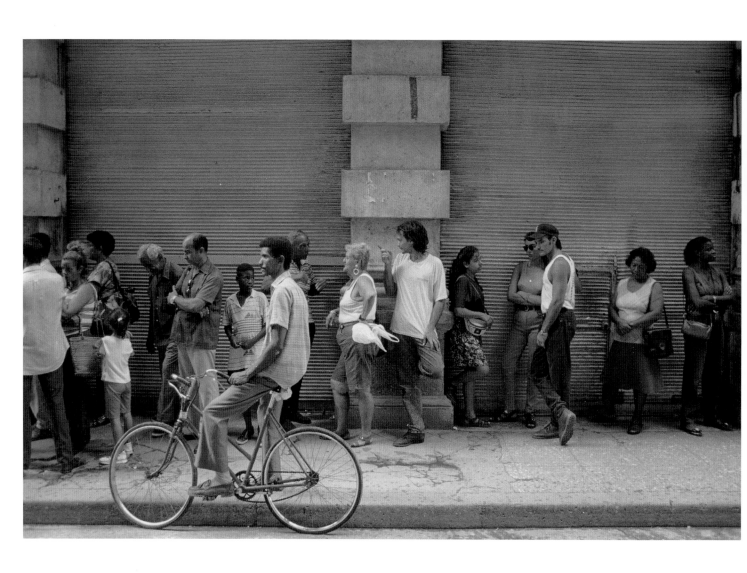

Waiting in line for food items at the **Libreta** *store*

industry is in shambles. And before that, millions were spent on cattle, and the cattle industry is in shambles. Before that, money was spent on coffee, and nothing has worked. We now produce less sugar, a lot less, than what was produced before the revolution. We have less cattle than we had in the fifties, and now we have twice the population. When you go to the countryside, you will see hundreds of secondary schools that have been built there, and they are empty. This government's incompetence is beyond belief."

I wasn't completely satisfied by Mario's explanation. I asked everyone I met where they thought the money was going. One man said, laughing: "I don't know where the money is going, except that it isn't going into my pockets!" Many blame the low salaries on the fall of the Soviet bloc, and they don't see how anything is going to improve, since the Soviet bloc is not coming back. One young woman was convinced it's part of the plan: by keeping everyone poor no one has time to organize to topple the system; they have to devote all their time and energy to the pursuit of the next meal. An independent taxi driver told me, conspiratorially, that it was a well-known fact that Fidel was putting all the money in his account in Switzerland.

The five supporters of the regime I spoke to accepted that salaries are low and money is scarce, but they blamed this situation on the United States and the embargo. Fidel, in his speeches, spreads the blame when it comes to the shortcomings of the Cuban economy. Everyone and everything are at fault, except, curiously, his leadership and his decisions. He primarily blames the embargo and the fall of socialism for the current crisis, which he has officially named the Special Period in Times of Peace, but in recent years he has also blamed incompetent managers (who routinely get sacked), corruption, absenteeism, inefficiency, capitalistic experiments, and even Soviet largesse, described in this December 25, 1993, speech:

To a certain extent, that enormous aid and help we received was bad for us. We became spenders and squanderers. We were receiving unlimited amounts of fuel. I want you to know that for years all we had to do was send a telegram saying that we were running out of fuel oil, that the gasoline was not enough, that we needed more diesel, and then ships were immediately sent with fuel oil, diesel or gasoline. It reached such a point that our fuel consumption, which was 4 million tons in 1960—that was when the blockade was imposed and we were left without fuel—was approximately 14 million tons 30 years later. We were even exporting oil.... Let me tell you that there came a time when our oil exports became our largest foreign exchange provider. That will give you an idea of how much we had as a result of that relationship. All that taught us to squander. This country had 89,000 tractors. Everyone went to ball games, to outings, to visit a girlfriend, and to parties in tractors.

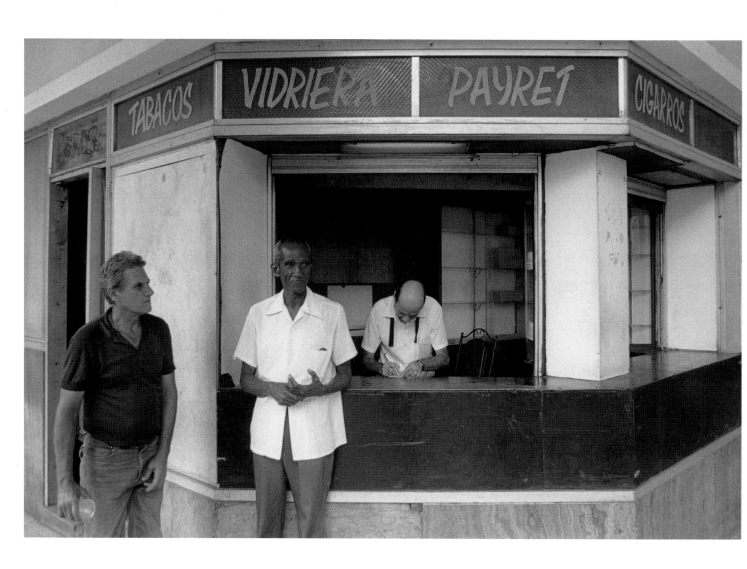

Government stand in Havana with nothing to sell

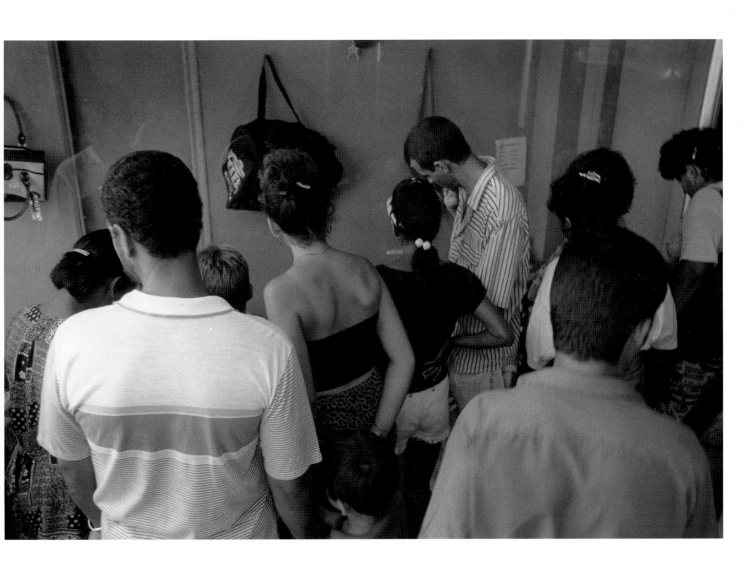

*Havana shoppers wistfully looking at the items
displayed in the window of a dollar store*

However, the most thorough and convincing explanation of why the economy is in shambles and why there is no money to pay the workers I owe to a mid-level government economist whom I saw often. I met him while we were both waiting for a table at the *paladar*. We sat together, and after dinner he invited me to his apartment for coffee. He wanted me to see it because the apartment was for rent, just in case I wanted to move from my current apartment. The apartment had almost no furniture, and there were stacks of books piled on the floor. He had just gotten divorced, and things were not much better at work. He described himself as a reformer, but he made it clear that he was not being listened to:

"Reformers all want the same things: more market mechanisms, more capitalism; but Fidel has always resisted market structures."

I asked him what I had been asking everyone. Where's the money? The economist corroborated what Mario had said. "There is no money. Seventy percent of all government enterprises operate at a loss. In a nutshell: The Soviet subsidy to Cuba during the eighties averaged around 4.5 billion dollars a year. They paid us higher prices than world prices for Cuban sugar and sold oil to Cuba at lower prices than world prices. The trade deficit between Cuba and the Soviets got as high as two billion in the eighties, and that shortfall was also subsidized by Soviet credits. How are we going to replace the Soviet subsidy? We aren't going to do it. It's not possible."

"Tourism seems to be growing fast in Cuba," I said. "Could that make up for some of the subsidy shortfall? I've also heard that biotechnology is doing well."

"Tourism is growing, but this year it will bring only 400 or 500 million dollars net. A lot of the money being made in tourism is being made by the foreign partners who invested in the hotels. Biotechnology is making less than the tourist industry, maybe 200 million. The rest of the economy is a mess. Sugar is in a downward spiral. We clear 300 to 400 million from sugar, certainly less than tourism—the first time this has happened in Cuban history. Ironically, the most profitable business Cuba has right now is the dollars coming from the enemy, the Miami Cubans. Since possession of dollars was legalized in 1993, remittances from Miami are bringing in 500 or 600 million a year. If you add all these, you get around 1.6 billion, so you can see we will never make up the 4 billion plus we were getting for free each year from the Soviets. We simply don't have enough money to import oil and food. The Revolution has always imported about 30 percent of our food needs."

"So what is the solution?" I asked.

"The only possibility is for us to produce more by allowing a free market of goods and services to function. Our problem is simple. We are not producing food because there are no incentives to produce. Everyone gets paid the same inadequate wage. And Fidel won't allow a real free market. Historically, whenever farmers in Cuba have been allowed to sell their own produce,

they've produced plenty of food. But you can count on Fidel to resist any attempts to free the markets. Castro has always exhibited an irrational hatred toward market mechanisms, entrepreneurs, capitalism, small private business, you name it. There are some free markets now, but they are overloaded with restrictions to prevent them from thriving."

Before I left, the economist told me a joke. Cuban jokes, he said, tell you all you need to know about Cuba. "Fidel goes to a hog farm and tells the manager: 'I want you to try this new diet on this pregnant sow. I've devised it myself and I think we could double the production of piglets.' Some months later the sow has the average number of piglets, five piglets. The farm manager is a little nervous but tells the district manager that Fidel's sow produced six piglets. The district manager calls the provincial managers and is happy to announce that the sow had seven piglets. This man is very excited and calls the national manager to announce the birth of eight piglets. The national manager calls the minister of agriculture and can't contain his happiness when he announces that Fidel's sow produced nine piglets. The minister is ecstatic. He calls Fidel and triumphantly announces that his diet has produced ten piglets. Fidel says: 'Just what I thought would happen. This is what we'll do: we'll export five piglets, and the five that remain will be allocated for national consumption.'"

✳

A FEW DAYS LATER I WAS PHOTOGRAPHing the monumental staircase leading up to the university of Havana, where rebellious students, including Fidel Castro, once massed to protest the many corrupt politicians in Cuba's history. Now, ominously, two government policemen were posted at the top and at the bottom of the staircase. A man sitting on a third-floor balcony nearby waved at me and invited me up. We sat on the balcony and talked. He was seventy years old, and he let me know quickly that he was not pleased with the current state of affairs. I wanted to know what were his impressions of Cuba before the revolution. He confirmed what I remembered.

"Politicians were crooks," he said, "but the economy was so vibrant that there was enough money left over to spread among the population. The salaries were more or less the same as now, except that dollars and pesos then were interchangeable, they had a one-to-one value, not the twenty-to-one exchange value they have now. In effect, the standard of living has gone down by a factor of twenty. In those days not one person in this city was hungry. In any cafe in Havana you could eat a meal with pork and rice and beans for fifty cents. Now you can't find pork, and if you find it, you can't afford it!"

"In your opinion," I asked him, "why is the Cuban economy in such terrible shape?"

"Fidel ruined everything in 1968 when he nationalized all the small businesses. Up to then, only the land and the big enterprises, like the sugar

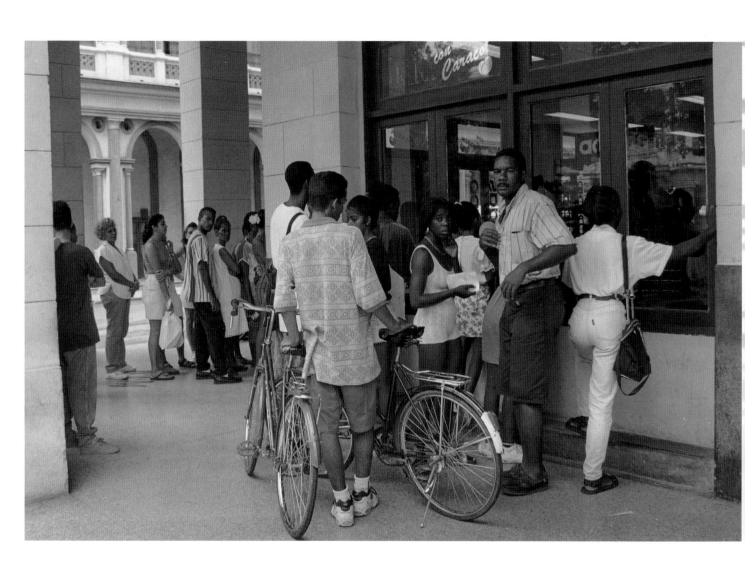

Line to get into a dollar store

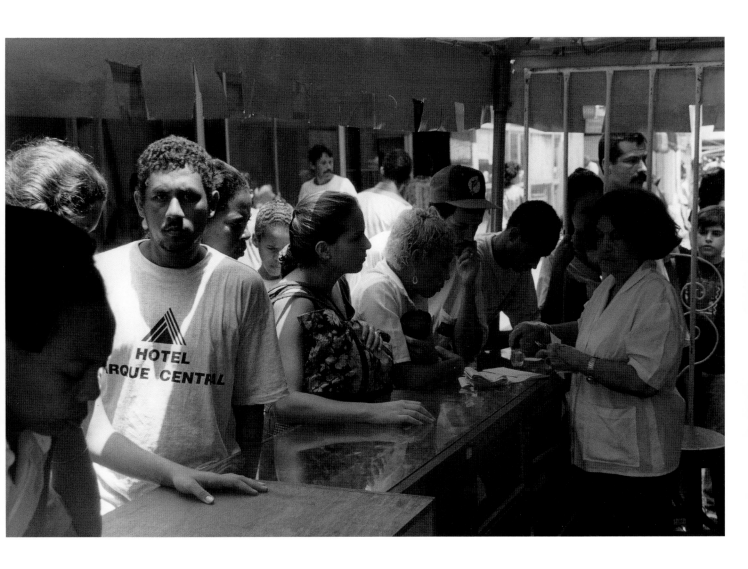

Outdoor store in Havana

mills, had been nationalized. But the bars, restaurants, stores, repair shops, small businesses—all those were individually owned. You could find anything, not as before, but you could find any kind of food, and have anything repaired. But Fidel has a problem. He wants to control everything. So he nationalized all the small businesses, even the vendors who sold food by the side of the road. When he did that, he ruined Cuba. This place has been a mess ever since."

I was curious to see how Fidel rationalized the government takeover of the fifty-eight thousand small mom-and-pop shops he nationalized in 1968, turning Cuba into the most socialized country on the planet. What the economist said about Fidel's semi-irrational hatred of the small entrepreneurs seemed accurate. Here is an instructive excerpt from a speech Fidel gave in March 1968:

When we spoke at the university some days ago, we referred to the cases of persons who made up to two hundred and three hundred pesos daily selling alcoholic beverages, bribing people, corrupting people. . . . That man who made three hundred or two hundred pesos daily did nothing for society. In turn, he drank the milk that a worker milked from a cow at five o'clock in the morning. He traveled on a bus, if he traveled by bus, driven by a worker who got up at six o'clock. Everything from the bread that he ate, the sugar, electricity, everything that he enjoyed daily, was produced by human work. In addition to this, that man who did not

produce anything—how much more than the worker did he make? He made twenty, thirty, forty, times more. That is the picture of injustice, the picture of inequality. It was truly painful that these conditions still prevailed in our country. An end had been put to the great exploiters, but many intermediate-level exploiters and many small exploiters still remain. Whatever it may be, large, intermediate, or small, exploitation must disappear. . . . That is why we are proceeding to the nationalization or intervention, whichever you like, of all types of private businesses left in the country. [applause] There will be nobody left who makes three hundred or two hundred pesos daily, nobody. No one will be left selling alcoholic beverages or running businesses of any kind.

And just in case people didn't get it, Fidel continued his lesson in socialist economics:

There were types who made a living—look at this new job—at the job of being a queue stand-in, and there were those who earned their living as queue stand-ins. But we are really going to find them out, those who earned their living standing in line, so that they will earn their living working [cheers, applause] and producing. It is the intention of the revolutionary government to raise an iron hand against all types of speculation, against all kinds of corruption, [crowd cheers] against all types of parasitism! [applause] So let it be known that

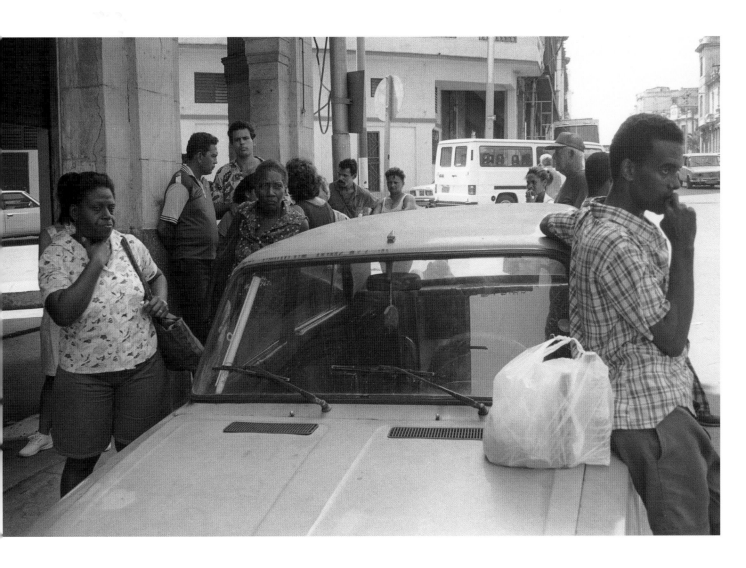

Waiting for an overdue bus in Havana

nobody, absolutely nobody, will be able to make a living here as a scoundrel. The scoundrels can be supported by the imperialists over there, with the income from exploitation of other peoples, the scoundrels, the vagrants, and similar parasites can be supported by the imperialists over there because they are their people. [crowd laughter] Our working people, however, are not here to support parasites of any kind! [applause] In whose name do we do this? In the name of the people.

In that same speech he explained that the only small private business he was not going to nationalize was taxi driving because that was an activity "which is due for disappearance because the cars get old and disappear. The number of cars do not increase." Little did he know that thirty years later those same old taxis would be merrily rolling along on the streets of Havana.

I couldn't resist hiring one of those scheduled-to-disappear private taxis, a 1958 black Cadillac, to take me on my mission to see the house where I used to live. I was thrilled to have found that particular model taxi because at the time I left Cuba in 1960, my grandfather had a chauffeur-driven 1958 black Cadillac. Now I sat again in the back seat as the driver drove up the long driveway, as I had done countless times when I lived there. The current Cadillac, though, was held together with duct tape and made many strange noises.

The house is hard to miss. It sits on top of a hill, at the high point of G Street, and was de-signed by an eccentric Russian architect whom my grandfather met on a trip to Europe. I got out of the taxi and asked to see the director of the house. When she appeared, I explained to her, smiling, that I was not interested in the least in reclaiming the house, but I had grown up in this building, and for sentimental reasons, it would mean a lot to me if I could see the house again. At first she was uncertain. Then she said she was sorry, I would have to go through official chan-nels, and mentioned the office I would have to approach.

"No, no, please," I pleaded. "I'm here purely on a personal mission. I just want to see my old bedroom, the ground floor, and I want to take a look at the garden and the mango trees where I used to play." When I mentioned the mango trees, she figured I was harmless, and took me on a complete tour. The house felt so familiar that it seemed as if I had only been away for the week-end. I must have filed away visual memories in my brain, and those files were reopened the mo-ment I stepped through the front door. I did not recognize the furniture, which was new, except for the heavy marble table by the foyer, presum-ably too heavy to move.

I stopped to admire the two-story-high stained-glass window by the main stairwell, which my grandfather had imported from Italy. It was more beautiful, colorful, and impressive than I remem-bered. I was thinking that I probably didn't look at things very carefully in those days. Back then, I also didn't think it was unusual to live in a house-

hold that had eight servants. All my acquaintances lived in houses that had as many servants. I've wondered many times what I thought then about privilege and social issues, and what I thought about Cubans who were not as fortunate as I was. Since I can't remember what I thought, I'm assuming I didn't think at all about such issues. All I vaguely remember is driving around Havana with Roberto, the chauffeur, looking out the window of the black Cadillac, and being happy that I was the person inside the car and not one of those out there walking on the sidewalks.

My old bedroom was on the ground floor, and now it was being used as an extra kitchen. There was a wonderful and familiar aroma in the room—they were roasting a pig in the oven. I took a flash picture, and when the cook turned my way, I told him I had slept in his kitchen for eighteen years. He stared blankly at me, possibly wondering why anyone would want to sleep in a kitchen. I went out to the yard and found the mango trees exactly as I remembered them. I wondered: what was the life span of mango trees? These ones had survived, unchanged and unimpressed, the last five presidents of the Cuban republic and thirty-seven years of the Revolution.

※

\mathcal{I} TOOK TAXIS EVERY DAY, NOT ONLY TO travel around the city, but also whenever I went to the beaches and parks on the outskirts. I never took government-owned taxis, which are brand-new Fiats with meters that charge close to what a Miami taxi charges. The private taxis are much cheaper, and funkier: 1954 Chevys, Fords, Cadillacs, all held together miraculously by their master mechanic owners, especially considering that few spare parts are available. Many of the operators are illegal, for the simple reason that the monthly fee you pay for the permit is high, four hundred pesos a month. In addition, to get a taxi permit you need to own the car, and it's difficult to buy a car. By law, the Ladas, the Russian cars, which comprise half of all the cars in Cuba, can't be sold. Their ownership is not transferable. Why? Because the Ladas were given to exceptional party militants and workers as a reward. Not exactly given, but offered the right to purchase, at low monthly payments. If a father wants to give the car he earned to his son, he cannot do it, because the son didn't earn it. If the father dies, the car goes back to the state. American cars are all 1959 model cars and older. They can be sold, since they were originally owned and not given by the state. But those cars are expensive, at least $1,000 if the car is running, and very few people in Cuba have $1,000. So many taxi drivers drive cars illegally, using cars that belong to their parents or are borrowed, loaned, or rented, and the profits are split. Basically, anyone with access to a car will take you anywhere for a fee. Cars in Cuba are money machines.

One day I was in a taxi going to Lenin Park, just outside Havana. I was going to the park to

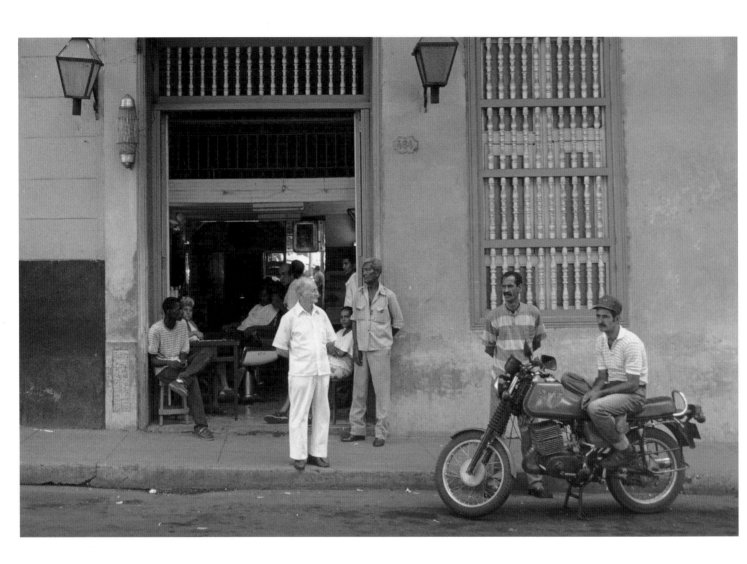

Barber shop in Havana

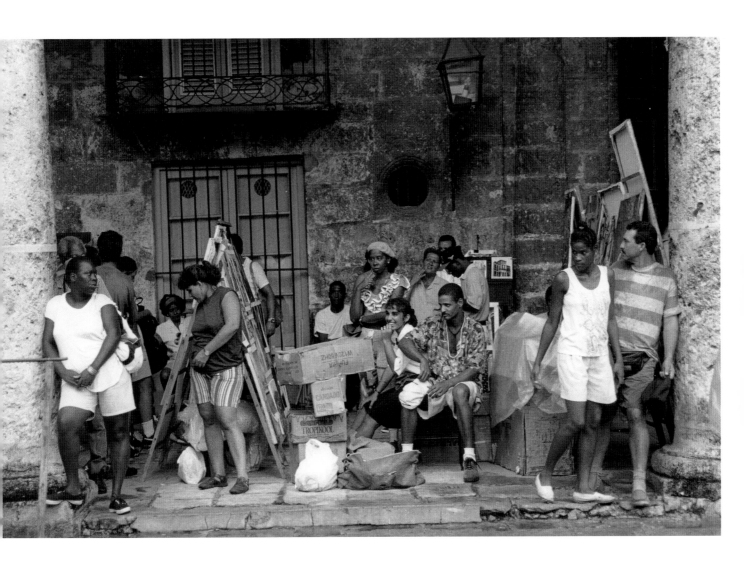

Scene next to the cathedral

photograph trees, thinking that if I had a show in Miami featuring Cuban trees I might be able to sell the pictures. The driver was a giant of a man, and I noticed that the car was a Lada. I asked him how he got the Lada.

"I was the best cane cutter in Granma Province in 1980. I was rewarded with this car."

I was impressed. I lived for the first eight years of my life in the sugar mill that my paternal grandfather managed in Camaguey Province, and I knew that cutting cane was a very hard job. I asked the taxi driver about it.

"It's the worst job I've ever done. The heat in the cane field is unimaginable. There is no breeze. When I started the cutting season I weighed 250 pounds. At the end of the season I came back weighing 180. I'm a tall man, so I was like a wire. When you cut cane, the leaves at the base emit these little particles that stick to the skin and itch like the devil. That's why you have to be totally covered with long sleeves and a hat, which makes the heat unbearable. When a field has been burned there's a dark resin on the surface of the cane that sticks to the clothes. After the day is over the shirt and pants will stand up by themselves, and the resin is hell to clean. You sweat so much in the heat that you have to drink gallons of water, and you have to drag the water with you. There are mosquitoes, bugs, snakes. It's terrible! But in the late seventies and early eighties, if you were good cutting cane you could make good money with bonuses. I made 1,000 pesos a month and I got this Lada. I'll never do it again. It wastes your body, and now they don't pay. There is no money, no Ladas, nothing."

I got off at the park to photograph the trees. The driver parked under a giant banyan tree and waited for me. I shot trees for a couple of hours and even got some pictures of the world's smallest bird, the *zun zun*, a tiny hummingbird the size of a big bumblebee that is native to Cuba. (When I got back I couldn't find the bird in the prints.) On the way back, the driver asked me where I was from. When he realized I was safe—an exile—he unloaded.

"This system is unworkable. If Fidel allows another Mariel, *no se queda un gato*. Not one cat will be left. I have to pay a four-hundred-pesos-a-month fee for the permit to drive a taxi, no matter what I earn. That's higher than any salary the government pays a high-level employee, and I have to pay that for the right to work on my own. I don't know what I'm going to do next month because the government has already announced that they are going to raise the fee we pay to three hundred *dollars* a month. I'm going to have to do it illegally. And on top of that I have to constantly repair this sixteen-year-old Lada, which like all things Russian, is junk. I supported this Revolution once. Now Fidel doesn't give a damn about the people. All he cares about is staying in power. This is a disgrace!"

He continued to criticize the government, all the while getting louder, and angrier, and more animated. He was driving fast, gesturing with both hands, and I was getting nervous. I had read

that Cuba is notorious for car accidents. I tried to calm him down by making a constructive suggestion. Maybe he could protest peacefully. For example, he could get other taxi drivers who were friends to drive down the Malecón (the road that follows along the seawall encircling the city), say Monday at noon; all the taxis would drive down the Malecón very slowly and create a traffic jam. Something like that. It would be a statement that drivers were not pleased about the $300 fee.

He laughed outrageously at my suggestion, throwing both arms up in the air, and said: "You must be kidding! What they would do is put a cannon at the head of the procession and blow everyone away!"

This man was furious—and he was legal. The next day I found out what happens when you don't have a permit. While walking and taking pictures around El Vedado I photographed a man working on a 1952 Buick. He was trying to fix a leaky radiator. I like those old Buicks with the circular vent holes on the side of the engine. We talked about the car. On weekends he tried to work with the Buick to make extra money. He had a good full-time job working on a construction brigade, and made two hundred pesos a month, but it was not enough. Unfortunately, he'd had some problems. He'd been fined twice, at 1,500 pesos a fine.

"That's a lot of money," I say.

"They don't care. In this place they do whatever they want. You can't contest anything."

"Why did you get the fines?"

"Why? Because the government doesn't want me to make money."

"Why not?"

"Because Fidel says that here no one is allowed to become rich. Look, all I want is a little extra money for food, shoes for my kid, I want to fix this house, little by little. See that bathtub sitting there in the yard? I bought it. Now I need the money for the pipes, and it has a little hole that has to be fixed. Little by little I'm improving my situation. But according to the government I'm a criminal for trying to earn a little extra."

"So how did you get the fines?"

"The last one, they caught me taking a fish to a *paladar,* and I didn't have a license to sell fish."

"One fish?"

"Yes, a kingfish. A 1,500-peso kingfish!"

"And the other?"

"Listen to this one. A friend asked me to take one of his relatives to the airport. I told him, fine, but you have to pay for the gas. He's a friend, and I'm doing him a favor. A policeman stops me. I don't have a taxi license because I had just bought the car and I didn't have the 400 pesos for the license. They fined me another 1,500 pesos. I went to the station and I made a scandal. I told them: 'Listen, I'm doing a favor to my neighbor. I didn't charge him. And you want to fine me 1,500 pesos for doing him a favor. What kind of a country is this?' They didn't give a damn. I broke the law. When they fined me over the fish, I told them: 'Look, can't you see that I can't live and support my family with my two hundred

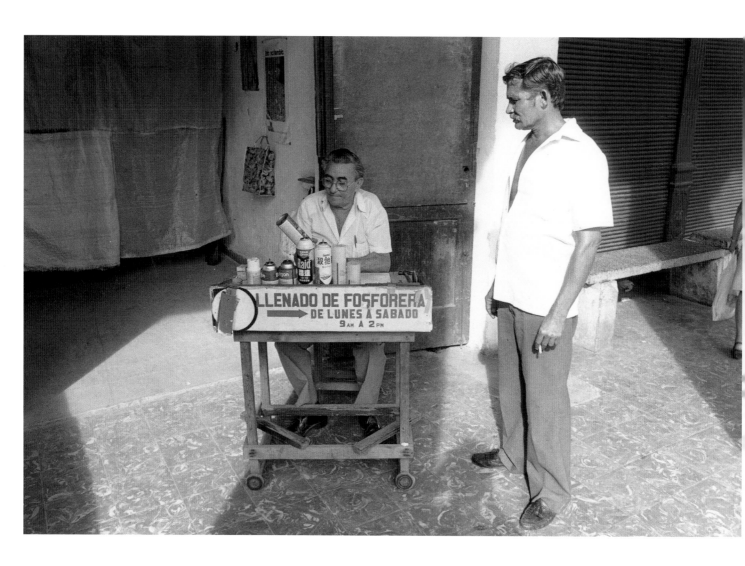

Self-employed man filling cigarette lighters

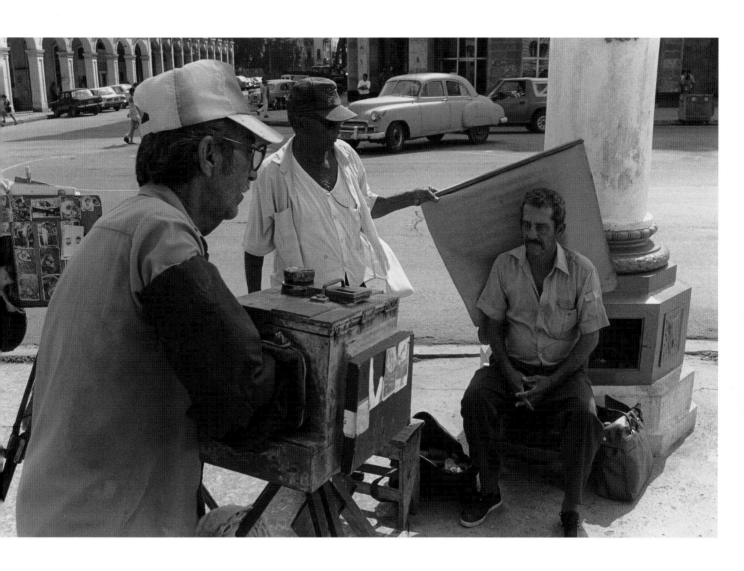

Havana portrait studio
(negatives and prints developed inside the camera)

pesos salary? I have to do something else to make something extra or we don't eat. What do you want me to do? You want me to steal? You want me to assault a tourist?' They told me the same thing. 'I'm sorry, but you broke the law. You can't sell fish without a license.'"

"Did you have money to pay the fines?"

"Of course not. I'm paying them at seventy-five pesos a month."

Throughout my stay I became very aware of this cat-and-mouse game played out every day in Havana—police stopping vehicles, motorcycles, street vendors at random to check permits. I watched it every day. It felt very oppressive. I witnessed this routine up close when I invited an architect and his wife to dinner. They had a Lada. We agreed for them to pick me up at my apartment.

We were driving down the Malecón, going to La Bodeguita del Medio in Old Havana, where Hemingway used to hang out and drink. I had gone there many times as a teenager.

A police car stopped us. "Papers," he demanded.

"Officer," the architect said, "did I do anything wrong? I wasn't speeding, was I?"

The officer didn't say anything. He gave the architect a hard look, possibly trying to determine if this man was one of the parasites Fidel mentions in his speeches. Then he took his time staring at me in the back seat. I cheerfully said, "Buenas noches." He continued to look at me but didn't answer. That one in the back, he must have thought, really looks like a parasite. The

officer carefully looked at the papers. He went to the back and checked the license plate, then looked again at the papers. Meanwhile, the architect was nervous. He was worried that he might be accused of moonlighting as a cab driver. His wife was more feisty. She said to her husband, "You are going to pay a fine over my dead body." Finally, after making us wait for ten minutes, the officer came back and said, "Bien." Everything is in order. We moved on and had a great many *mohitos* at La Bodeguita.

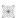

*T*HE GOVERNMENT IS CLEARLY NOT happy with the many independent taxis, and with independent employment in general. The word *independent* is not a favorite word in the rhetoric of the Revolution. Recently there has been a flowering of associations of independent journalists, independent economists, and independent unions, and all are constantly harassed by the government. In his recent speeches Fidel has made it clear that the current craze of independent groups and entrepreneurial activity, made possible by tourism and the dollars floating around, is an evil that the state is tolerating during the Special Period, but this evil will be carefully watched. In his July 26, 1995, speech he warned the entrepreneurs:

Wide-scale tourism, the depenalization of convertible currency holdings, institutions that

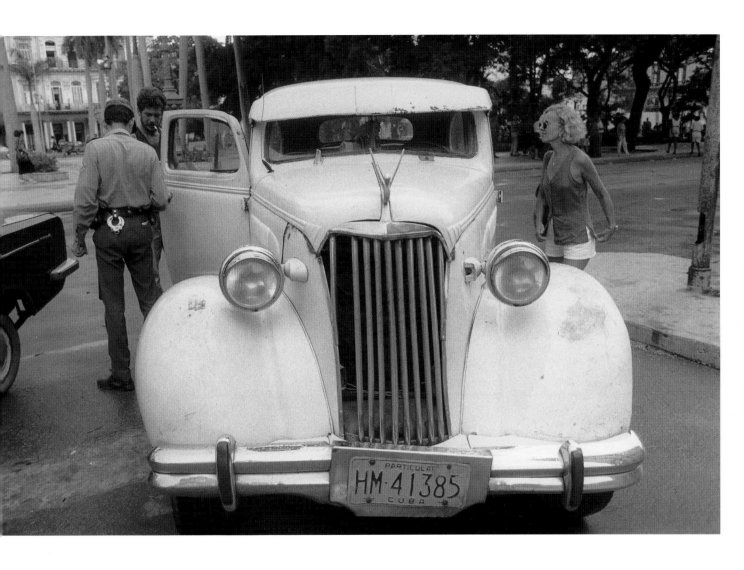

Guard checking a taxi driver's papers in Havana

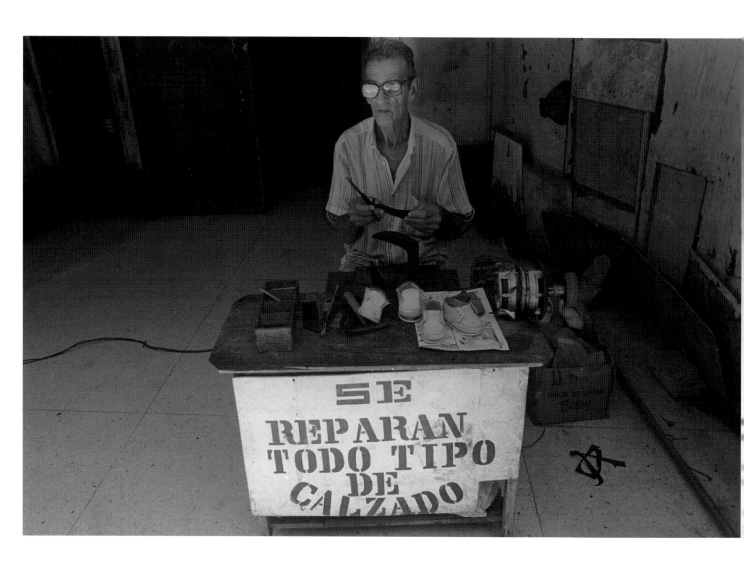

Self-employed man repairing shoes

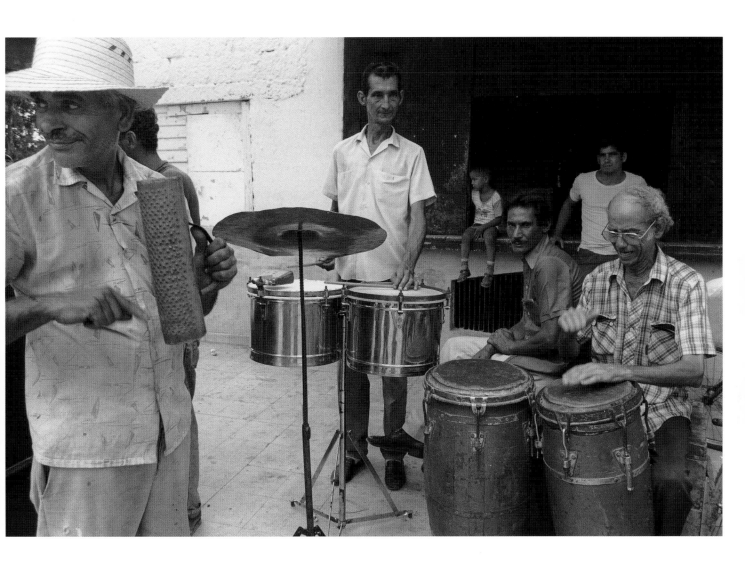

Band in Holguín

sell these currencies, are all measures that became unavoidable but that also carry an inevitable cost. It appears as if some, by looking at their demeanors and lifestyles, seem to relish their roles as entrepreneurs. Others seem committed to create firms or small establishments at whatever costs simply to handle foreign currencies, and on many occasions simply to lavish these resources and violate specific guidelines regulating these holdings. The struggle that the party and government will have to undertake against these trends before they turn into a cancer that devours our ethics and revolutionary spirit will have to be a colossal one. We will have to be implacable toward those who violate our most sacred principles. The blood of so many was not spilled for nothing to allow such pathetic conduct in this most difficult hour of the Fatherland.

But in the meantime, while the evil exists, the state insists on getting its cut of the self-employed worker's pie. It solves two problems. It's another badly needed source of income for the government, and it ensures that no one makes excessive profits, which Fidel won't allow. What infuriates everyone in Cuba's small but rapidly growing private sector is the restrictions, *las trabas,* and the escalating taxation, which lead everyone to believe that the government is not really serious about permitting self-employed workers and small enterprises to thrive.

When the family restaurants were first allowed, in 1993, owners had to pay a monthly fee of one hundred pesos. There were other restrictions, as well. The restaurants, as well as all the other self-employed categories, couldn't hire anyone outside the immediate family. Restaurants couldn't have more than twelve seats, couldn't serve seafood, and couldn't have live music. Nevertheless, by some estimates, a thousand restaurants sprouted all over Havana. Within a year, the government decided the owners were making too much money and closed them down. In 1994 the government reversed course, and the restaurants, now called *paladares*—after a restaurant in a Brazilian soap opera popular in Havana at that time—were allowed again, but with the monthly fee increased to a hundred *dollars*. In the two years since then, the fees have increased from one hundred to two hundred, to four hundred dollars, which is what they were paying when I was in Cuba.

The owner of the *paladar* I went to was furious. He was doing well with a monthly fee of $200, but it was difficult to survive with a $400 fee. And in October 1996 the fee was scheduled to rise it again to $750, which he felt would drive him out of business. When I asked the owner what he was going to do, he said, "I'll do it illegally, or I'll have come up with something else."

I asked him what was the logic of the government when it made moves like that.

"There is no logic, but there is a reason. The government says they don't want anyone to get

TONY MENDOZA

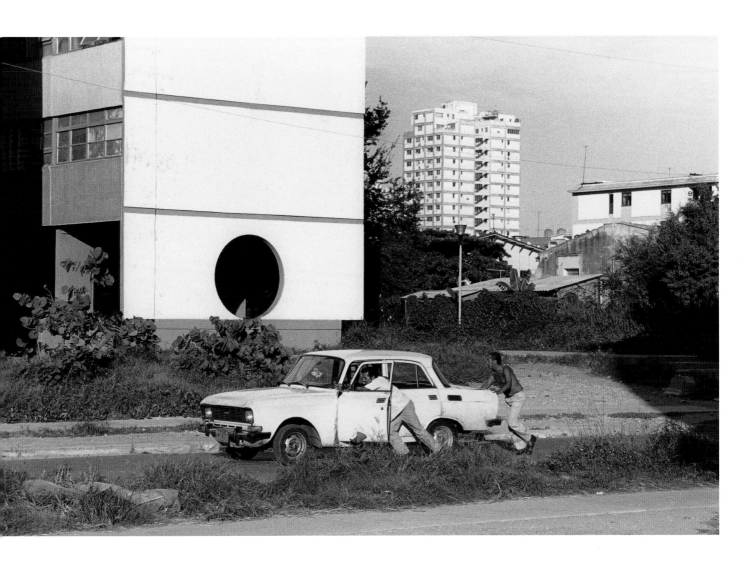

Men in Havana trying to jump-start a car

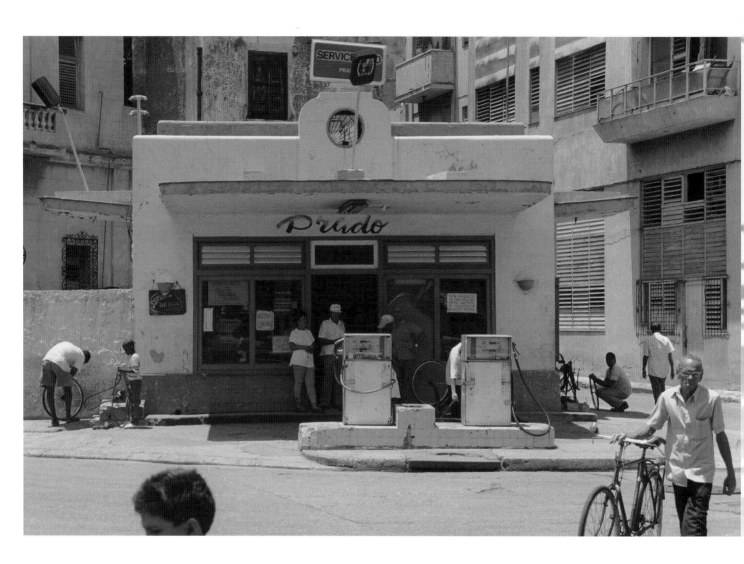

Gas station in Havana

Van waiting for wheels and an engine in El Vedado

rich. But everybody understands the real reason. Fidel doesn't want too many people to be economically independent. When people are economically independent, they are also politically independent. They don't go out on weekends to cut sugar cane. They don't go to the plaza for the rallies. They won't follow orders because they have nothing to lose."

The *paladar* owner has not been going to the plaza for years, and neither have most of the self-employed workers I talked to. How Fidel has filled the plaza in the past and other mysteries were explained to me by a woman in her early thirties whom I met in the line for ice cream at Copelia, the giant ice cream shop in El Vedado. I was writing in my diary and she wanted to know what I was writing. I told her I noted down what people said to me in conversations, so I wouldn't forget. She said, "I can tell you a few things."

We got our ice cream and sat down at a small table in the park. She let me know right away that her father was a high government official. She said it in an offhand way. Her dad fought with Fidel in the Sierra and he has worked with Fidel since then. Her family has certain privileges, like a car with a driver, and she has traveled abroad. I assumed that she was warning me not to ask any indelicate questions.

"I take it, then, that you're a supporter of the revolution."

I was hoping she was. I wanted to hear the official response to the problems and abuses I was seeing in Cuba.

"I'm not a supporter at all!" she exclaimed, as if I had just insulted her.

"You must have interesting dinner conversations at home."

"We don't talk about politics. He knows what I think. The problem with high government officials like my father is that they are insulated. They talk among themselves. They read reports. They don't talk to the people in the streets. And like Fidel, they don't want to hear criticism."

"What do you do?"

"I'm an agronomist. But I'm not interested in working any more. What for, for ten dollars a month? I prefer to come here and eat ice cream. I was a militant up to five years ago, not because I agreed with what is going on here, but because I was expected to succeed in my job, and advance, and the only way you can move up here is if you are a militant."

"What exactly is a militant?"

"First you are a member of the Communist Youth, and then the party. You are expected to do extra work. You volunteer, you cut cane, you build schools. You go to the plaza to every speech Fidel gives, you show up at every demonstration. In meetings you're an outspoken supporter of the revolution. It's the only way here to advance and get extra privileges. It was especially true in the eighties. You could get things—televisions, even cars. If you didn't cut cane, or go to the plaza to listen to Fidel, that was noted down in your work record. When you see demonstrations in Cuba in support of the regime, don't think for one second

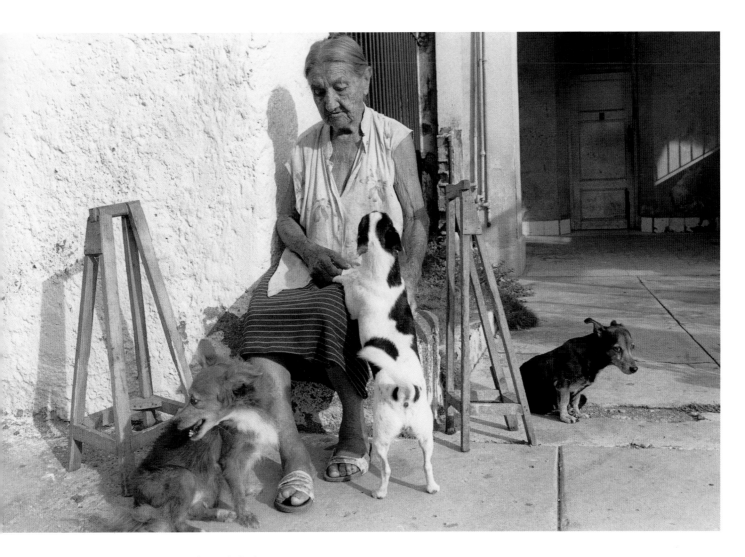

*Woman with her dogs. She said she lives on a
pension of six dollars a month and she's lucky
because her three dogs like to eat rice and beans.*

Not much happening at Havana Harbor

Horses in a Havana park

it's a popular demonstration. Office workers meet at the office and get taken there in trucks. It's part of the job. If you don't show up, you can get fired. You certainly won't be promoted. Most militants are hypocrites. My boss was that way. She speaks a perfect line and doesn't believe a word. She has no problem lying. She's a great actress. They call that here the double morality. Everybody practices it or practiced it. Times are different now. They got nothing to give so why lie and volunteer? I never could do it. I'm too honest. I did it for a while, hoping to advance, but it gave me tremendous indigestion. Don't laugh, I had to see a doctor."

"So it looks like you're not going to get the good jobs in agronomy."

"No. I don't work. I don't listen to Fidel, I don't volunteer, I don't lie. My husband works and he lies for the entire family. Everything about this system is a disaster. Take the medical system, which the government raves about. I'll tell you a story. I have a young son. The law here says that for the first seven months you have to breast-feed your kid. But I had a problem: I didn't produce enough milk. The baby started to cry because he was hungry. So I went to my doctor to get a ration coupon for formula. You'd think it would be a simple matter. It *would* be in the rest of the world, but in Cuba it was a nightmare. I had to go to seven buildings, all over Havana, and wait forever in each, till I got the paperwork done and approved. Getting the permit was a full-time job for five days. It would have taken two weeks if I

didn't have use of the family car and had to move on public transportation."

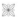

Wherever I went in Havana, children wanted me to take their picture. Photographs in Cuba have become rare and precious objects, maybe as rare and precious as they were in the nineteenth century, since very few Cubans can afford cameras, film, and processing. The children were always hoping that my camera was the kind that makes instant pictures, and they were disappointed when I told them that I had the other kind. But they still wanted their picture taken. Often I started by photographing one or two kids playing in a street in Old Havana, and within minutes I'd have all the kids of the block raucously clumping together in front of my camera. The political and economic frustrations that seemed to be afflicting the adults were not affecting the children. They were endlessly joyous and energetic. The lack of toys didn't seem to affect them either. They went fishing, they made their own toys, and I saw games being played that I'd never seen before. In Cuba, if there is a ball, there are countless games possible. If there is a ball, a bat, a park, and more than three kids, there is a baseball game on.

I took four or five rolls of film every day. Mostly, I photographed anything that caught my attention: buildings, cityscapes, people, cats, dogs. The photographs that I rarely took and wanted

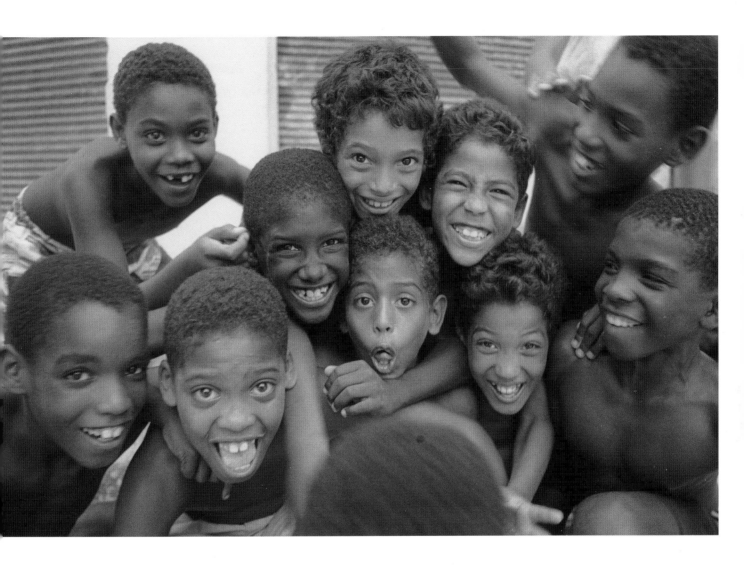

Boys in Old Havana

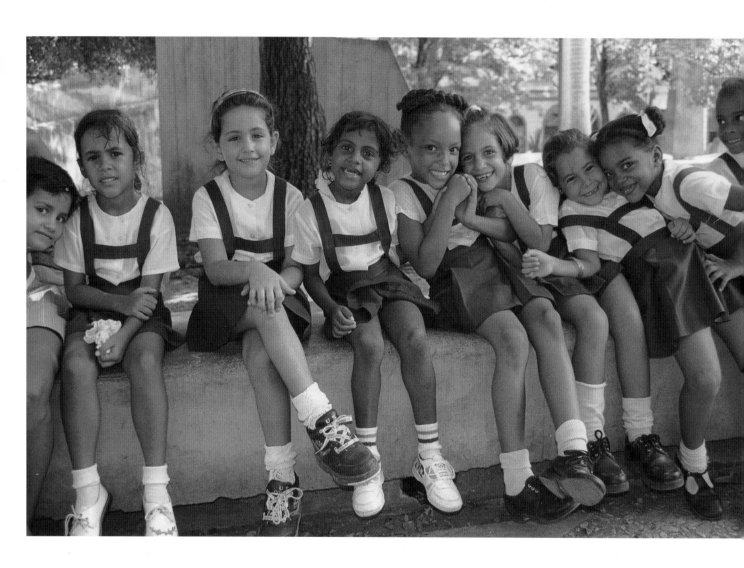

Schoolgirls during recess in Havana

to take were pictures of the police constantly harassing and carding independent workers, but I was worried they would ask for my journalist permit, which I didn't have. A Spanish journalist I met at the *paladar* told me that if Cuban officials decide you're a journalist without an official permit, they'll confiscate all your film. For a photographer, this is a nightmare, and it happened to him on his first trip to Cuba a year ago. I didn't have such bad luck, but I was told three times by officials that I couldn't take pictures. I took a picture inside the dollar supermarket in the Focsa building, and a guard immediately warned me that photographs were not allowed there.

"Why is there such a rule?" I asked.

"Photographs are not allowed here," he said a second time.

An explanation, at least, was given when I was about to photograph from the gate the former home of my best friend during my teenage years. Two guards suddenly appeared and asked me what I was doing. When I explained, they suggested I quickly move on. I was now photographing the home of a high government official. The third time was more predictable. I went to photograph the home built by my great-great-grandfather, where my father grew up. It was now an army headquarters.

I ran into the economist again, riding his bicycle on one of the steep hills in El Vedado, and I invited him to eat at the *paladar*. After dinner, we went to his place for coffee. I told him that I was starting to think that I was onto something; that

the feisty, antigovernment self-employed workers I was meeting every day held the key to the future. If this sector gained strength, it would form the foundation for the free market economy that someday would inevitably follow socialism. A stronger independent sector would allow more people to leave state jobs, the government would have less leverage over workers, and even the socialist politicians would have to start responding to the private sector's needs.

"Yes, I agree," the economist said, "but nothing here is that simple. It won't happen as long as Fidel is around. The problem with Fidel is that he bought Che's ideas about the New Man, and the New Man never arrived. We're still stuck with the old model! I'm going to take you back to the sixties, when a debate was raging: how to structure a socialist economy and what incentives to use. One group wanted central planning and state control of all major production facilities, mixed with some market mechanisms and material incentives. The other alternative was complete centralized planning, with no market mechanisms but only the use of moral incentives, socialist conscience, and idealism to motivate the workers. Che was the spokesman for the second alternative. He advocated that socialism had to create a New Man, someone with *conciencia*, someone who worked not for personal gain and wealth, like the capitalists, but for the good of his fellow man, and for the Fatherland, because it was the right thing to do. Fidel sided with Che. He saw— during the Bay of Pigs, the Missile Crisis—that

he could mobilize the Cuban masses by appealing to nationalism and pride. He was confident that socialist workers could be moved to work by moral incentives, by appeals to their heroism, dedication, sacrifice, and above all, their love for Cuba. Mass mobilization of workers, usually working after regular work hours as unpaid volunteers, was the key to this policy. This approach won out, and Fidel decided to give it a test run. He declared that in 1970 Cuba would produce ten million tons of sugar, which was 30 percent higher than the biggest harvest in Cuban history. There were no studies. Fidel simply decided on the ten million, a nice round figure. The ten million became, in his words, "a sacred goal," and the entire island was mobilized for the two-year effort. Every worker in Havana was sent to the fields on weekends to plant and cut cane.

"I've read that that harvest didn't succeed," I said.

"It was a total disaster! The goal was never met, and the intense concentration of resources and manpower on the sugar industry created chaos in all the other areas of the economy, especially the production of food crops and tobacco. What followed was a long period of the alternate approach, central planning with limited market mechanisms and some material incentives—the Soviet model. Most people agree that this was the golden age of Cuban socialism, and it lasted from 1971 to the middle eighties. Rationing persisted, but there was generally enough food, and the government could point to its successes in education, health care, not to mention sports,

which were, to some degree, undeniable. All possible, of course, because of Soviet subsidies. In 1980 important reforms were initiated; the state allowed the introduction of free farmers' markets, where the prices of foodstuff would be set by the laws of supply and demand. But there were limitations. The markets could only occur locally, and no middlemen were allowed; that is, someone with a truck could not take the produce produced in the country and sell it in Havana. Still, the farmers' markets were a huge success, and the amount of food available increased appreciably. The farmers were happy and the public was happy. Also in 1980 the government legalized some self-employment: taxis, hairdressers, carpenters, and some professionals were allowed to start their own offices. Again, there were limitations. Self-employed workers could work only after they completed their regular state jobs, and there were high fees and taxes."

"How successful were those measures?" I asked him.

"Very successful and very popular. Especially the free farmers' markets, for the obvious reason that certain food products could be found again. But starting in 1982, Fidel became disappointed in these policies and started denouncing the self-employed workers and the farmers in his speeches. He felt too much capitalism was corrupting Cuban socialism and what proved to be the fatal sin—too many self-employed workers and farmers were making too much money. The Revolution is grounded on socialist equality, and the self-

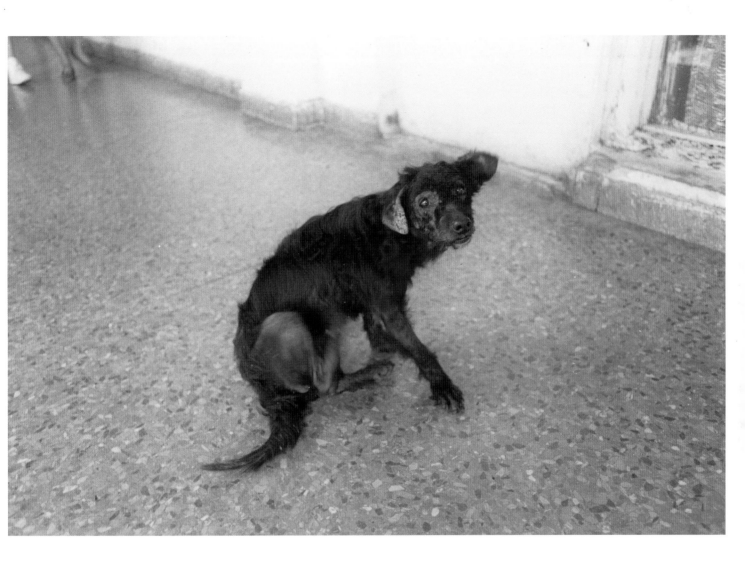

Dog in Havana

Dog in Havana

employed workers were making a mockery of equality. Hundreds of self-employed workers were arrested for becoming too rich, and the taxes for independent workers were doubled. But the Cuban entrepreneurs persisted. In 1986 Fidel put an end to it all when he announced the Process of Rectification of Errors [PR]. The errors that were rectified were the market reforms—which according to Fidel appealed to the base and selfish impulses of man. The free farmers' markets were eliminated, as well as self-employment. Fidel continued to insist that the New Man step forward. The purpose of the PR was to get back to Marxist-Leninist basics, and specially to the concept of mass mobilizations and volunteer work."

"So what happened with the PR?"

"It was a another disaster! The purified socialist economy was incapable of producing the products and services eliminated by the PR. The economy started on a steep decline. This decline accelerated abruptly and unexpectedly in 1989 with the cutoff of Soviet preferential trade agreements. The PR was immediately canceled, and in 1990 an austerity program ensued, the Special Period in Times of Peace. Soviet oil shipments ceased, and there was little money to buy it in the open market. Oil imports dropped from thirteen million tons in 1989 to five million in 1993. Raw materials and parts from the socialist block were difficult or impossible to replace. Factories had to be closed due to lack of fuel or raw materials, and unemployment skyrocketed."

"So self-employment had to be allowed again."

"Yes, self-employment was allowed again at the Fourth Party Congress, in 1991, but Fidel refused to permit the free farmers' markets, even though the public wanted them back. And again, self-employed workers would have considerable restrictions: professionals and university graduates would be excluded, it had to be done after regular work hours, self-employed workers could not employ anyone outside their own family circles, and they would be subjected to a monthly fee. Still, Fidel was unhappy about these concessions and it took two years of foot dragging, until September 1993, to enact the self-employment laws. Other reforms were set in motion by the economic catastrophe of the early 1990s: the dollarization of the economy in August 1993; the free farmers' markets, allowed again in October 1994; free artisan markets in December 1994; the active promotion of foreign private investment, in various decrees in 1993–1994. But whenever this government makes an opening it lays the groundwork to take it back. Undermining the whole idea of self-employment is Law 149, instituted in May 1994, which states that any excessive accumulation of riches is illicit. Thus anyone making too much money through self-employment is breaking this law and can be put in jail and have their assets seized."

Before we called it a night, the economist told me another economic joke.

"A bad Cuban dies. Up there the gatekeeper gives him a choice: 'You can choose between a capitalistic hell or a socialistic hell.' The Cuban

Dog in Havana

wants to know what's the difference. The gatekeeper replies: 'In the capitalistic hell we are going to boil you in a very hot pot of oil, not boiling, but very hot. We are going to make you walk on a floor with small nails protruding, not huge nails, and then we are going to whip you with an electric whip which has a current of 110 volts.' 'And the socialist hell?' the bad Cuban asks. 'Well, it's all the same, except that in the socialist hell the oil is going to be boiling, the protruding nails are going to be huge, and the whip is going to have a charge of 220 volts.' The bad Cuban doesn't hesitate for one second. 'I'll take the socialist hell!' The gatekeeper says: 'You are really dumb, you know. Don't you see that the pain is going to be twice as bad?' The bad Cuban says: 'No, because they won't be able to find the wood for the burning pot of oil, the nails will be stolen, and there are very few chances that they will have electricity.'"

✳

I'VE LOOKED UP FIDEL'S SPEECHES during the time of the Process of Rectification. I was curious how he had explained to the Cuban people why the farmers' market and the other self-employment categories had to be eliminated. From Fidel's point of view, garlic, my favorite spice and the most essential ingredient in Cuban cooking, was destroying socialist equality. From a speech he gave at the Communist Party meeting in December 1986:

It was hard to see the people selling garlic there at any price with one hectare of land and working a few hours a year and getting a profit in the peasants' free markets of fifty thousand to sixty thousand pesos a year, which is what one of these highly qualified specialists in surgery earns in twelve years. There were incomes here—I figured it out—which would have taken a surgery specialist of the best we have in the country sixty years to earn.

In another speech, given January 15, 1987, garlic comes up again:

The cooperative movement was doing fine until the moment that a man who had a hectare of land was able to make a twenty thousand peso profit by selling garlic, or any other product that was scarce on the market, or by selling at very high prices. . . . The man who was making a fifty thousand peso profit with his farm did not join the cooperative system. One or two peasants with a very high revolutionary awareness did join. We know of some who put aside their substantial profits and did join the cooperative movement. However, as a rule, the man would begin by building a huge mansion on his little piece of land. No one ever told this man that if he joined the cooperative movement he would have electricity and a good home. He bought his material around the place. A man with fifty thousand pesos is always going to get all the cement he needs. He may have bribed

Boys fishing off the Malecón

Schoolgirls in Havana

the man on the farm who had the cement. . . .
In this manner he built his house. I wonder
how many of you could get a man who has
built this huge house to join a cooperative.

Another problem, according to Fidel, that arose from the farmers' markets was the middleman. This middleman, mentioned in an April 4, 1982, speech, had a weakness for plantains:

Well, a plague of middlemen began to arise around this [farmers' markets]. It was a plague of middlemen who did not produce anything. They purchased and hoarded. There was a man who had fifty thousand plantains. There were fifty thousand plantains in a militant's warehouse. It is a curious thing, how they corrupt the militants; fifty thousand plantains.

But what has surprised me the most while reading Fidel's speeches is how insistent he has been on the principle that he and Che advocated—that socialist workers should be motivated by moral incentives, socialist conscience, and idealism, as opposed to pay. It's truly a capitalist manager's dream. In the same April 4, 1982, plantain speech he clarified this position:

Of course, it is already known that in capitalist countries, eminent persons earn huge sums. That is why revolutionary conscience, communist conscience, internationalist conscience is required to work for one's people at a much lower salary, in much more modest and more harsh conditions. That is the kind of technician, of revolutionary, of communist that we want to form. [applause]

Indeed, nothing seems to make Fidel happier than when entire contingents of workers are working for free. This is from a July 26, 1987, speech:

What is happening with the micro brigades? It is amazing. Many micro brigades are willing to do construction work after their regular quitting time. They are willing to do this work after completing their micro brigade work. This does not cost the country a single centavo more. We can build a new Havana and resolve the problems we have accumulated without spending more money, just by mobilizing the people, rationing the efforts of the people, and properly directing the people. The only spending involved would be equipment maintenance and fuel. This is truly amazing; this is truly extraordinary within this rectification process.

And here is the ultimate revolutionary worker, a New Socialist Man that Fidel discovered and described in his January 9, 1989, speech:

On January 4 I was amazed when we gave out diplomas to the EXPOCUBA workers who had done extraordinary things. I remember one worker who worked and worked and was always there, day and night. That comrade put

*in 3,500 hours of volunteer work. I later
calculated this, and it is the equivalent, it is the
equivalent of approximately two years of
volunteer work after working eight hours a day!*

One of the reforms the economist had mentioned in his review of the socialist Cuban economy was the legalization of the dollar in 1993. The idea behind that move was to get the Miami Cubans to send dollars to their relatives in Cuba. Some American scholars estimate that as much as $800 million is going to Cuba through remittances. Eventually those dollars end up in government hands through dollar stores. When I was in Cuba, it was obvious that the dollar was king. Peso stores were completely empty, but dollar stores and dollar restaurants had anything you might want. I ate lunch every day at the Burgi, at H and 23rd Streets. This is a McDonald's clone, owned by a Spanish chain, and the prices are in dollars. Lunch at the Burgi—which consisted of a hamburger, French fries, and a drink that looked and tasted exactly like a Coke—cost three dollars. What surprised me was that the Burgi was fairly crowded at lunch time, and almost everyone, except for a few tourists, were Cubans. Three such lunches would deplete the average state salary of eight dollars a month, so it was clear that the Cubans eating at the Burgi were not examples of the New Man.

I bought beer and sodas for my apartment at the dollar supermarket at the Focsa Building. That store was also crowded, mostly with Cubans. Fidel never wanted to legalize the dollar, and now he has a problem: those who are most likely to not support the Revolution—the Cubans with relatives in Miami, the black marketers, the self-employed workers, the taxi drivers—have access to dollars and are ostentatiously taking lunch at the Burgi. Not surprisingly, these are the people Fidel despises. These are the people who have no socialist *conciencia*, interested only in personal gain, in capitalistic greed. Fidel's people are the socialist workers with plenty of *conciencia*, those who volunteer in the cane fields, the government functionaries, the university professors, the military and security people. Unfortunately, these people are being paid a tiny sum in pesos, tend not to have relatives in Miami, and in general have no access to dollars. Peso workers are, to put it mildly, upset. In addition, another group that has historically supported the Revolution, the Black population, has no dollars. Only 3 percent of the Miami exiles are Black.

I learned how upset some of the traditional supporters were one evening on the Malecón, when I started a conversation with a man who was fishing. He said he had been a party militant since the sixties.

"And now?" I asked him.

"I don't believe in this anymore."

"Why not?"

"You want to know why? The idea behind Marxism is a very beautiful idea. It seduced me. But it has a great error. It doesn't work. The flaw is this idea that we are all the same, that we have

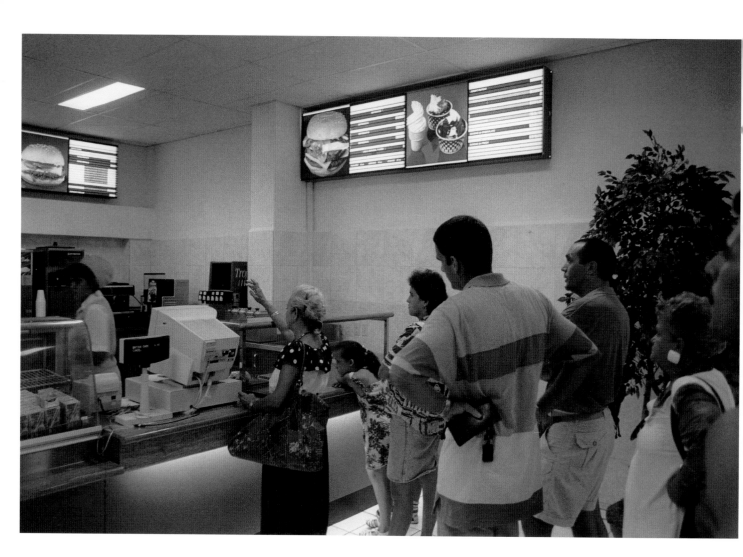

The Burgi at 23rd and H Streets in Havana.
Prices are in dollars. Three lunches at the Burgi
would deplete the average monthly salary.

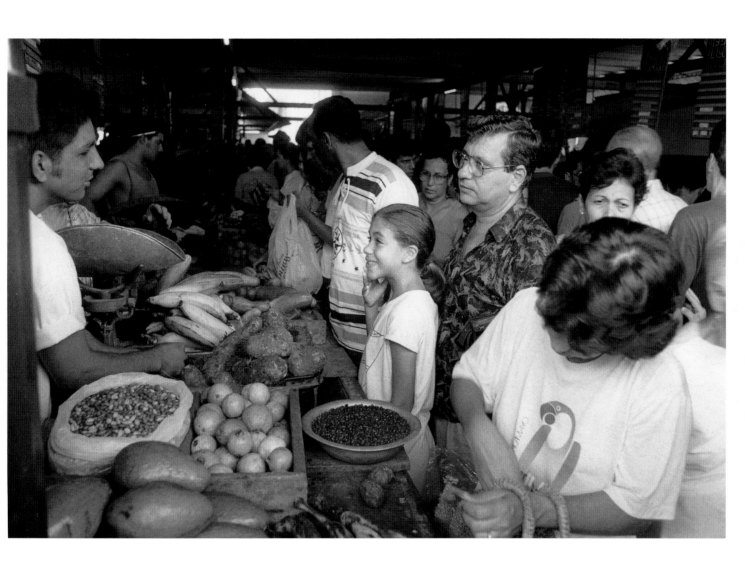

The free farmers' market on B Street in El Vedado

the same needs, that we should be paid the same. *Not true!!* That's the flaw. See these hands. They are different from every other pair of hands. See these eyes, *also different!* This brain of mine, *different!*"

He picked up momentum, getting louder as he went through every remaining part of his body. I started to worry for my physical safety; this man was losing it.

"For thirty years, I've been working like a dog for this revolution. Thirty years of volunteer work, thirty years of sacrifice. *What for? What for?* We have nothing here. I don't have anything. I have the shirt on my back, this pair of pants, these shoes. That's all. But all these scums around me, the black marketers, the illegal vendors, the good-for-nothings with relatives in Miami, who haven't done shit for the Revolution, they are doing great. They have dollars. It's not fair. *It's not fair!*"

Then, suddenly, he started crying.

<div align="center">✳</div>

FIDEL OPPOSED MAKING THE DOLLAR legal and predicted what would happen in his July 12, 1992, speech, one year before the law was approved:

Every jinetera around would be looking for dollars. They could come to the hotels if they did a trick with a tourist and were paid in dollars. . . . If we were to do that, the effect would be disastrous because it would promote all sorts of immoralities and shady deals. It would be incredible if we were to say that Cubans can pay in dollars, because that would establish great discrimination between Cubans who have dollars and Cubans who do not. The most honest people would never see the hotels. The most loose, corrupted, dealing, scheming people, those in contact with foreigners, would have dollars.

I met many of those corrupted, scheming, dealing individuals. One of them, a fairly well dressed man, approached me right outside the Habana Libre Hotel, where I had gone to treat myself to a luxury breakfast.

"Amigo, how would you like to buy a box of Cohibas cigars, handmade, exquisite cigars, the best we have, at half the price you pay at the airport?"

"No thanks," I said, "I can't take them back because of the embargo."

"Amigo, then can I offer you a bottle of rum, Habana Club, seven years old, much cheaper than in any store?"

"No thanks, I'm not really a rum drinker."

"Amigo, maybe I can interest you in this. I have an apartment near here, with air, for fifteen dollars a day. It's very clean."

"Thanks, but I have an apartment already."

"Amigo, let me finish! I can supply this apartment with a divine young woman, a real beauty."

"No thanks," I said. I couldn't wait for the next offer.

Empty Spanish Hotel in Varadero Beach

Boys swimming off the Malecón in Havana

"Well, if you need me, I'm always on this corner."

In the two years that have passed since my trip to Cuba, the friction caused by the dollar economy and the disparity between the citizens who have access to dollars and those who earn pesos seems to have intensified. From reports by independent Cuban journalists and recent speeches and government documents, one gets the inescapable impression that things are not boding well for the socialist conscience. The document excerpted below, the draft version of the Declaration of the Fifth Congress of the Communist Party, published in Granma in August 1997, makes various references to the problems caused by the dollar economy and blames—who else—the Americans:

The United States tries to erode the ethical foundations of the Revolution in order to weaken it from within and undermine our sovereignty. It uses every means possible to encourage selfishness, anarchy, and consumerism among us and attempts to promote the subversion of order, the fracturing of unity, while facilitating the destabilizing activities of small annexationist groups who aspire, with financing from abroad, to return to the yoke of the United States and the restoration of capitalism.

The same document, one paragraph later, does not paint a pretty socialist picture:

Lumpen elements, criminals, and all those who contribute to the violation of laws and the transgression of order objectively serve our enemies. Each case of corruption that is not stamped out in time serves to undermine the image of our democracy, to the benefit of those who hope to eliminate it. Today, we cannot accept indifference and inaction on the part of revolutionaries. Our patriotic and socialist values are also endangered by the abandonment of moral principles and norms, a lack of solidarity, insensitivity, and the frivolous fascination with U.S. models and symbols.

The best-paid self-employed workers in Cuba are the *jineteras*. In the old days, prostitutes were called *putas*, but that word had a seedy and dishonorable connotation. *Jineteras* are never called that. *Jineteras* are different. They have college degrees. Their activity is seen by Cubans as an entrepreneurial activity, as opposed to a vice. If a *jinetera* has a "date" every night she could make $2,000 a month tax free, which in Cuba is a fortune; thus the temptation is high. A brain surgeon would have to do brain surgery in Cuba for eight years to earn an equivalent amount. Fidel never tires of repeating in his speeches how the Yankees had transformed prerevolutionary Cuba into their gambling den and their brothel and how the elimination of casinos and prostitution during the first days of 1959 was a testament to the high moral character of the Revolution. Now times are different. I saw *jineteras* everywhere in

Havana, always dressed in black, like New York artists, and I didn't see any getting arrested. I'm assuming that the high moral character of the Revolution has come down quite a few notches because Cuba desperately needs the tourists and their dollars. I got the strong impression that tourism in Cuba is predominantly sex tourism. What I suspect really bothers the government is the fact that the *jineteras*, the highest-earning self-employed individuals in Cuba, cannot be taxed as every other self-employed worker is taxed, because the *jineteras* are illegal and therefore don't officially exist. I wondered how Fidel was dealing with this moral quandary and the flowering of prostitution in the Havana of the Special Period. I expected him to rationalize it somehow, but I didn't expect him to say this, in a July 12, 1992, speech:

We had to accept tourism as an economic need, but we said that it will be tourism free of drugs, free of brothels, free of prostitution, free of gambling. There is no cleaner, purer tourism than Cuba's tourism, because there is really no drug trafficking, no gambling houses. There are hookers, but prostitution is not allowed in our country. There are no women forced to sell themselves to a man, to a foreigner, to a tourist. Those who do so do it on their own, voluntarily, and without any need for it. We can say that they are highly educated hookers and quite healthy, because we are the country with the lowest number of AIDS cases. There are nearby countries which have tens of thousands of AIDS cases. Therefore, there is truly no tourism healthier than Cuba's.

Jineteras accosted me every day, and I had a standard reply: "Sorry," I'd say, showing my wedding band, "but I'm married."

"So what, that's no reason. Your wife will never find out."

"Yes she will. My wife has extrasensory perception. She'll know." Still, I wanted to know how these women felt about what they were doing.

I was eating dinner at the *paladar*. Three Italian men came in with their Cuban companions. They got a large table near my table, and the three men sat together at one end of the table and spoke in Italian to each other. The women were ignored. They sat at the other end of the table and talked among themselves. My table was near this group, so I moved my chair closer to the women and started a conversation. The Italian men didn't seem to mind. I learned that the women earned from twenty-five to fifty dollars an evening, but included in the deal was the dinner, and afterward they'd go dancing. They saw it as a date with a fifty-dollar tip. One of the women in the group was finishing her medical internship. She said it was very tempting to earn fifty dollars in one night, eat a good dinner, talk to foreigners,

Man and daughter jumping off the pier of the old Havana Yacht Club

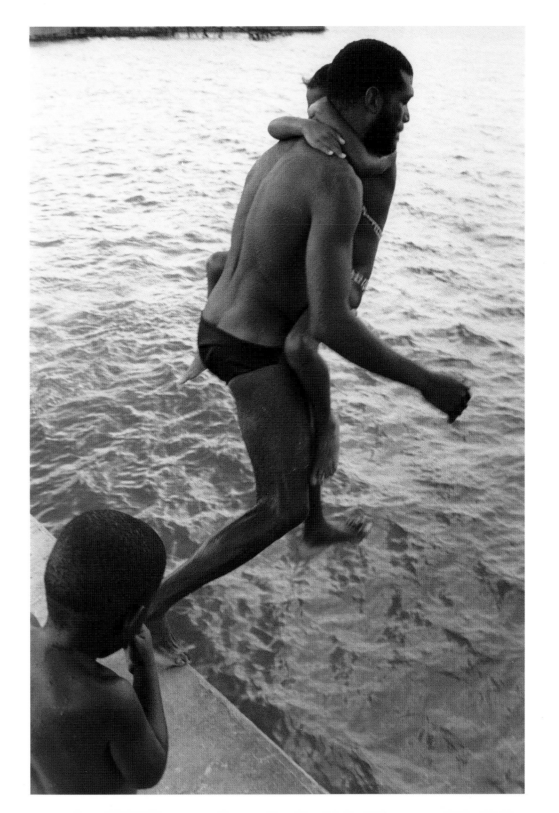

find out how the rest of the world lives, have fun. She could buy whatever she wanted and help her family. I asked her if her parents knew what she did to earn those dollars.

"Of course they know. How else in Cuba am I going to make this kind of money and buy the things we are buying? I don't tell them the details, but they know."

"Are they upset?"

"Not really. *Hay que resolver.* I'm supporting the entire family."

"Aren't you afraid of AIDS?"

"No. There is no AIDS in Cuba. I wouldn't dream of having sex without a condom. Nobody here does it without condoms."

"So, what do your think about the Revolution?" I asked her.

She looked at me as if I were from Mars.

"You still talk about the Revolution? I don't talk about that. It bores me. I'm not interested in that."

※

THERE ARE MANY UNUSUAL SELF-EMPLOYMENT categories, such as the people who set up a table and chair on the sidewalk and offer a service that must be unique to Cuba—filling up cigarette lighters. One day I discovered a still more unique and decidedly macabre way to earn a living. My apartment building was two blocks from the Malecón, and every morning I went to the seawall. A man sold coffee there, and I liked to start my day sit-

ting on the seawall, drinking coffee and staring at the ocean. I noticed a man equipped with fins, mask, and snorkel, a spear gun, and a tiny buoy trailing behind him, swimming straight out every morning until he disappeared. I used to spear fish, so I was very interested in what he was doing. One day I caught him before he went out. He was an impressive looking fifty-five-year-old man, with long white hair, a carefully trimmed beard, and a bronzed, muscular body.

"I see you swimming out every morning. How far do you go?"

"Depends. Some days I snorkel by the wall. What I do is I retrieve fish hooks, nylons, which I sell. When I go for fish I swim out seven miles. At other times, I go looking for bodies. I find bodies even further out, ten miles out."

"Did you say bodies?"

"Yes, for example. When people left on rafts and they were unlucky, a storm got them, and they drowned. Remember the rafters? Many left, but many ended in the sea. Many took necklaces, rings, money—I've found wallets with two thousand dollars underwater."

"Why do you find the bodies ten miles out? Did a boat sink there?"

"No. Between Varadero and Camarioca there is a trench, about ten miles out. Rafters who drown at sea get brought back by the current and they get caught in this trench. I dive down there for the jewelry and the wallets. I find gold medallions, rings, and I sell them."

"Don't bodies float?"

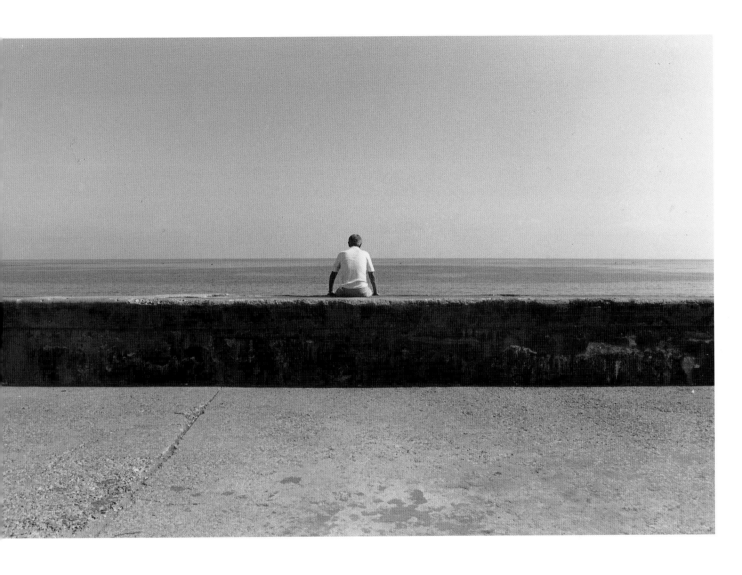

Man sitting on the seawall in Havana

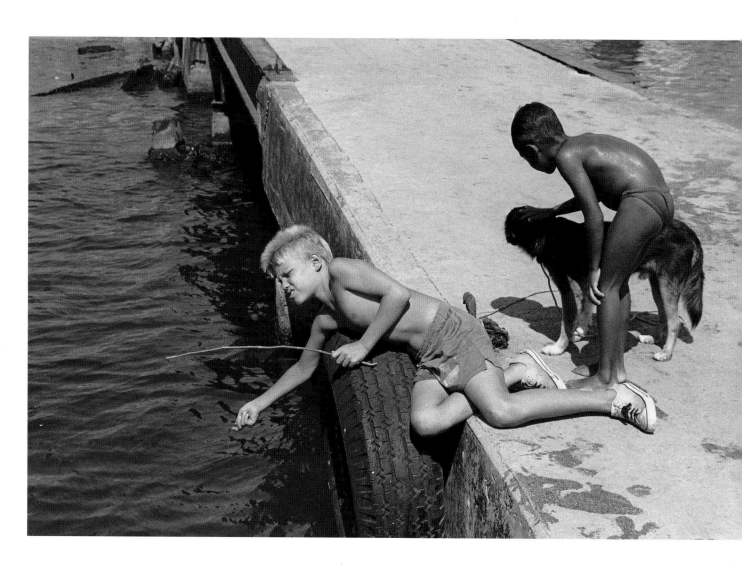

Boys fishing in Cojimar

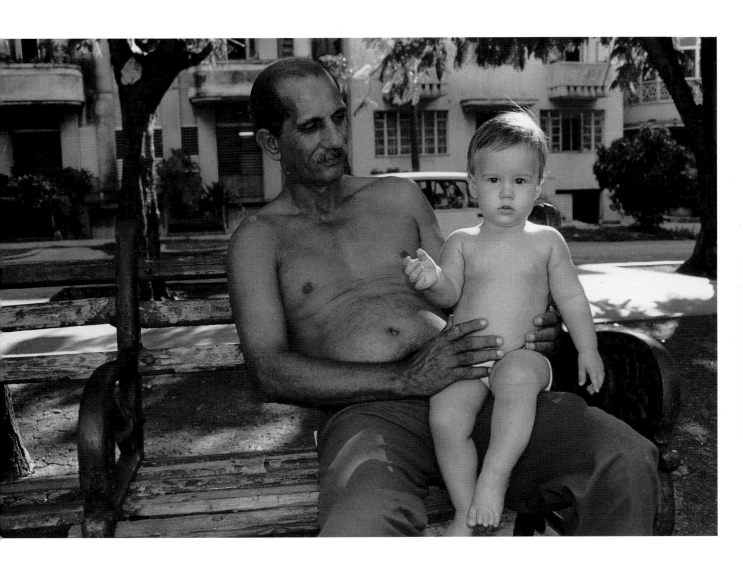

Man with grandchild in a Havana park

"When the lungs fill up with water they sink. Usually I only find the skeletons. And the rings are still there."

"So the fish eat them?"

"Well I've seen a leg in one place, a head in another. Lately there haven't been too many rafters since the U.S. started returning them. So I've been going fishing."

"You say you go out seven miles. Why?"

"That's where the fish are. The shore is fished out. Also, all the fish by the Malecón are polluted. Where I get them, they are clean. The place I go to, a reef, it's only 100, 120 feet deep. It takes me about 40 seconds to go down, and I stay down looking for fish for a minute. I used to last 3 minutes when I was young, but now I'm only good for 2, 2 1/2 minutes."

"What happens if a boat sees you out there by yourself, seven miles out?"

"They usually slow down and take pictures."

"Aren't you afraid when you are out there far from shore, alone, without a raft? What if you get a cramp?"

"No, I believe in destiny. I'm going to die when destiny decides."

"But aren't you increasing your odds? Aren't you afraid of running into a huge shark?"

"No. I know sharks. They don't bother me. Sharks are afraid of sounds. Sometimes they swim around me, and if I want to get rid of them all I do is tap my knife quickly against the gun. They hate that metallic sound and they take off. If I'm close to shore and I see a shark I see only one thing—a big dollar sign. I'll shoot him and try to bring him in. People here eat shark."

"Are there any Great Whites here?"

"No, no, that's our salvation! They don't come here. No, I'm never scared at sea. I'll tell you this. The way I feel in the sea, when I'm out there five or six hours off the coast, I feel at peace, because I'm among beings that love me, that give me life. I'm more scared when I get on land. People, I don't understand them. They do strange things, they say strange things, I look at their faces and they look terrible. I don't know what's happening, I don't understand humanity. I don't want to talk to people. They look at you and say things that aren't true. Sincerely, I feel much better with the fish in the ocean than with people on land. They are the ones that give me life. They are the ones that help me."

※

I WENT TO THE COLÓN CEMETERY IN El Vedado, which is famous for its beautiful tombs and mausoleums. I wanted to photograph the tomb of my great-great-grandfather, Antonio González de Mendoza, my namesake, as well as the tomb of my grandfather on my mother's side, Luis Menocal. My mother has never seen her father's tomb, and I wanted to take pictures for her. The other man, my namesake, was the first chief justice of the Cuban Supreme Court, in 1902. He had been a law professor at the University of Havana for many years before starting a

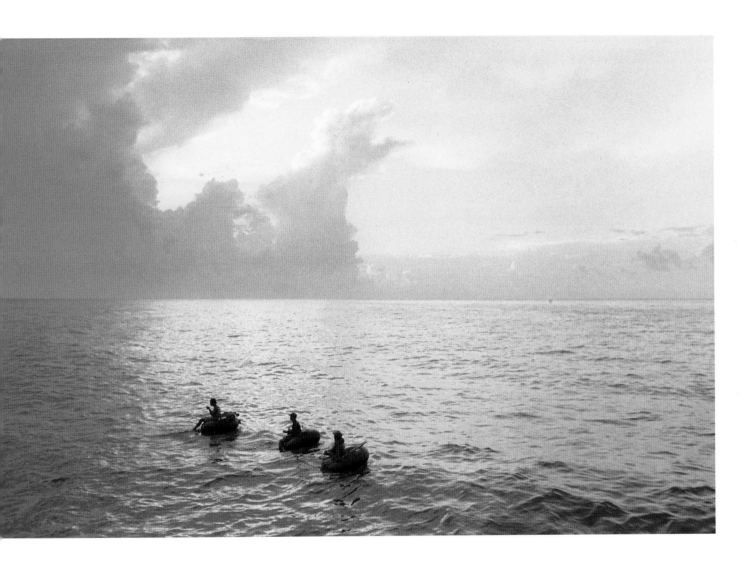

Havana fishing vessels

very successful law firm and was also elected mayor of Havana in 1878. My father spent the first years of his childhood in the house that Don Antonio built in Old Habana, at 31 Amargura Street. From my father's description, and the description of the household printed in Don Antonio's obituary in *La Discusión*, in 1906, it was more a palace than a house:

There, in that unique household, live together all the branches of the family, the sons with their respective wives, daughters-in-law, the daughters with their respective husbands, sons-in-law, and forty-five grandsons and granddaughters. An army of servants: six cooks and their helpers, twenty nannies and maids, ten coachmen and pages and a world of supplies and services.

Two tables are set each noon and each evening, one for the children and one for the adults an hour later. The rite of passage from the "little table" to the "big table" is fraught with significance, announcing, within the family, that one of its members has come of age and forecasting the introduction of that member to public or social life.

My father grew up in the same house with fewer first cousins—only thirty. There was enough manpower among the cousins to field two baseball teams, and they played every day. That affluent past and the huge Mendoza household on Amargura street has intrigued me in recent years, and I wanted to see and photograph the house, which, curiously, I was never interested in seeing when I lived in Cuba.

I found Amargura Street, but the house numbers were faded or missing, so I was having trouble finding 31 Amargura. I found number 25, and a few doors up the street I entered the courtyard of what had once been a mansion and now looked like a tenement. People there told me I was at 29 Amargura, so I went next door. Unfortunately, 31 Amargura Street was now one of the headquarters of the Cuban Army. The man at the front desk was incredulous when I told him I was there on a personal research project and I wanted to take some pictures.

"No, absolutely not. Taking pictures here is not permitted," he said, alarmed.

I pleaded to see the courtyard, explaining the family connection. I showed him my passport and told him that the man who built this house had the identical name, but he wouldn't budge. As I was leaving, an officer who had witnessed the conversation took me aside. He wanted to show me something. To the side of the lobby there was a large and elaborate wood paneled door. It now led to a storeroom, but an old and elegant brass plate still read: Bufete Mendoza, the name of the law office Don Antonio had started.

Now I wanted to see his tomb. The procedure at Colón Cemetery is simple. You go to an office and tell the people there the name and the year

when the person was buried. They pull out some very old registry books. In a few minutes the young woman who attended me found the location of Don Antonio's tomb. She wrote down the address on a piece of paper, and a guide was sent with me to find it. Both the young woman and the guide knew Don Antonio's history. I think for the first time in my life I was impressed by my lineage. I liked the tomb; it was a small monument with a crucified Jesus looking toward the sky. I took some pictures and sat there for a while, trying to make some sort of connection with my very successful forefather, maybe hoping to receive some crucial insight about success from the twilight zone, when it started raining. It was one of those sudden and extreme tropical downpours, and I was worried that my camera would get soaked. I looked around and saw a mausoleum across the street with an open door. I ran for it.

Inside I found another man, older, bearded, a guard. We were there for half an hour, waiting for the downpour to end, and inevitably, we talked about the Revolution. He supported it 100 percent. I asked him about some of the problems I was seeing, but he wasn't aware of many problems. He had been an army officer and had retired but found retirement to be intolerable. He wanted to continue to help the Revolution, so he volunteered as a guard. I asked him about his past, and it turned out that this man had made history. Not only had he fought with Fidel in the mountains, and thus earned his impressive beard,

but also, he had gone with Fidel on that first trip to New York after the triumph of the revolution. I was very excited by this unexpected run-in with a historical person, but all I could think of asking him was:

"Is it true that you cooked chicken on the rug in your rooms in the Hotel Theresa?"

"Yes," he said, "something like that did happen."

\mathcal{I} HAD BEEN IN CUBA FOR ONE WEEK, and the man at Colón was the first person I had talked to who supported the Revolution. The second person was a very enthusiastic Black taxi driver. I had gone to the old Havana Yacht Club, a place full of memories for me. I took some pictures there, talked for a while to a couple sitting on the pier, and then took the taxi back to El Vedado. The driver was delighted to hear I was an exile living in the United States.

"Isn't it amazing, the U.S., the most powerful country in the world, and you can't squash poor little Cuba! You keep trying but you can't do it!"

"I don't think the U.S. is trying that hard to squash Cuba."

"Oh, no? What do you call the Bay of Pigs, all those murder attempts on Fidel, the embargo?"

"Yes, they did all that, but that's the past. The embargo has been there for thirty-six years, and it's not that effective. Cuba has learned to work around it."

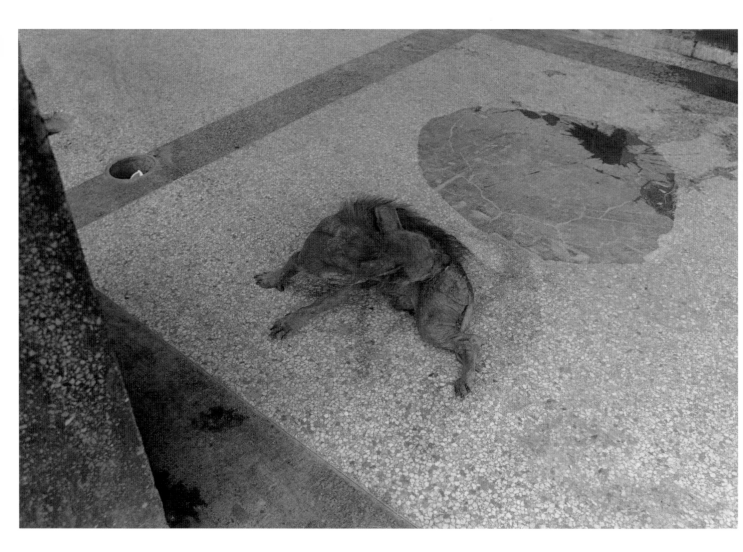

Dog in Havana.
Most dogs I saw were in terrible shape. Many have been
abandoned to the streets because of food shortages.

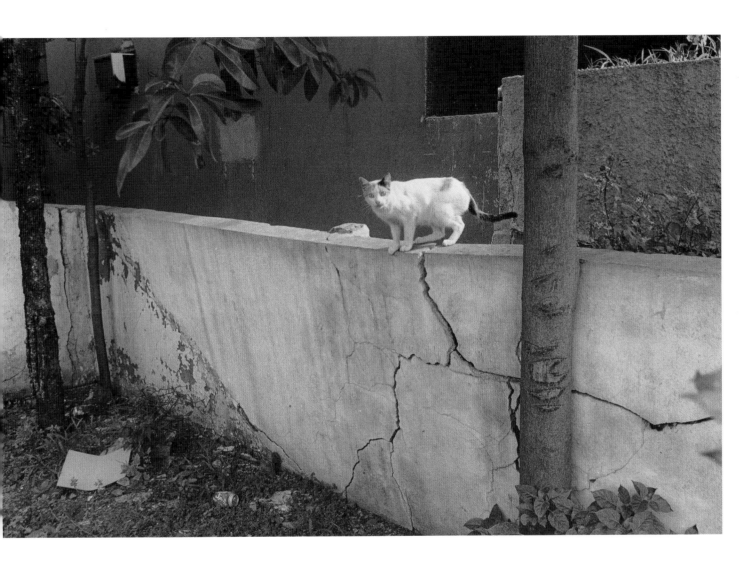

A rare cat in Havana

"It's not that easy, my brother, and how about tourism? Our problems would disappear if millions of American tourists were allowed to come to Cuba."

"Maybe. Maybe not. Don't you know? Americans don't like Fidel. Why do you think they would want to come?"

"They would come for our *mulatas*," he said, smiling.

"You're not proud of that, are you?"

"No, I'm not. But if we didn't have the embargo, we wouldn't have *jineteras*. And what can you tell me about Blacks in America? Everyone knows how Blacks are treated in America. That's why Cuban Blacks haven't emigrated. What happened to Rodney King could never happen in Cuba. Here there is no discrimination. Blacks, Whites, we are all brothers here. Look around Havana and tell me if you see any discrimination."

"You're right. I don't see it and I'm not going to defend discrimination in the U.S. But an argument can be made that Blacks in the U.S. are better off now than thirty-six years ago. I could also make an argument, just by looking at this city, that all Cubans, Black and White, are much worse off than they were thirty-six years ago. How many Cubans have left this island? Over one million, out of a 1959 population of six million. And how many have died, desperately trying to flee this island in flimsy rafts? That says something, doesn't it?"

"Not necessarily! A lot of the immigration has been economic. How many Mexicans emigrate to the U.S.? Many more than from Cuba. Besides, thirty-six years ago a poor Cuban couldn't get an education or see a doctor. That's not true now. Cuba was a playground for the marines and the Mafia. Cuba was one big brothel."

"How old are you."

"I'm forty."

"How do you know that? You were three."

"Everyone knows that. You don't have to live history to know history."

"I was around then. There were brothels. But they were in a certain area, mostly in an area by the port called Colón. There wasn't one brothel in El Vedado, where I lived, there wasn't one brothel here in Miramar. All Cuba was not a brothel. There are brothels in Paris, but all France is not a brothel. And about the Mafia, the Capri was owned by the Mafia; there were two or three other Casinos the Mafia was involved in. Cuba was not the playground of the Mafia. And about discrimination. In Cuba discrimination was never a historical problem, when you compare it to the U.S., where it has been. The hero of the Cuban war of independence, Antonio Maceo, was Black. Batista was elected president by popular acclaim in 1940. He was mulatto. In America George Washington could never have been Black, and a mulatto president never could have been elected in 1940."

"And what can you tell me about crime, my brother? In America you have to wear bulletproof vests to go into the streets. Here there is no crime. What are you going to say about that?

How are you going to defend America when it comes to crime?"

"I'm not. There is crime in America. In the town where I live, though, in Grandview, Ohio, there is very little crime. I don't have one bullet-proof vest in my closet."

"Of course. You are the oppressor. You are White, rich, and you live in a rich neighborhood."

"You're wrong again. Grandview is a middle-class town. I'm as middle-class as you can get. Now I want to ask you a question. I read that the dissident organization, Concilio Cubano, was going to have a big meeting this past February in Havana, but the meeting was not held because Fidel arrested most of the participants the week before the meeting. Can you defend the practice of arresting dissidents?"

"Yes! They were instigated and paid for by the CIA."

"Do you really believe that?"

"Of course. The CIA tried to kill Fidel, I don't know how many times. And you don't think they would instigate this meeting to create internal conflicts?"

When I got out of the cab, he gave me this advice:

"You know, I've thought a lot about how you can solve the crime problem in America. It's very simple. Why don't you copy the Cuban system, the CDRs [Committees for the Defense of the Revolution]? Put a CDR on every block like we do here, and the CDR would know everything about every citizen on each block. All they would

have to do is call the police and have the criminals picked up. You would have no more crime."

The alleged connection between the CIA and the Cuban dissidents explains why Fidel refutes the idea that the dissidents and human rights activists in Cuban prisons are prisoners of conscience. This is what Fidel had to say on the matter in an October 20, 1994, interview with Jean-Luc Mano, a French journalist:

MANO: *You know that your opponents—and you have them too even here in Cuba—say that it is also the country with the most prisoners per capita. For political reasons.*

CASTRO: *Oh no, not political—that I totally deny. . . . But that depends too on what you call a political prisoner. It is a question of doctrine, a question of philosophy. Some of the greatest jurists do not ascribe the status of political prisoners to the counterrevolutionaries.*

MANO: *Generally speaking, a political prisoner is a person you put in jail for not sharing your views.*

CASTRO: *No, we do not have that kind of people here. We may have people in jail here for acts of sabotage, for plotting subversion and counterrevolution, for seeking to destabilize the country, for working in close cooperation with the CIA to destroy the revolution. And no one can deny our rights to defend ourselves.*

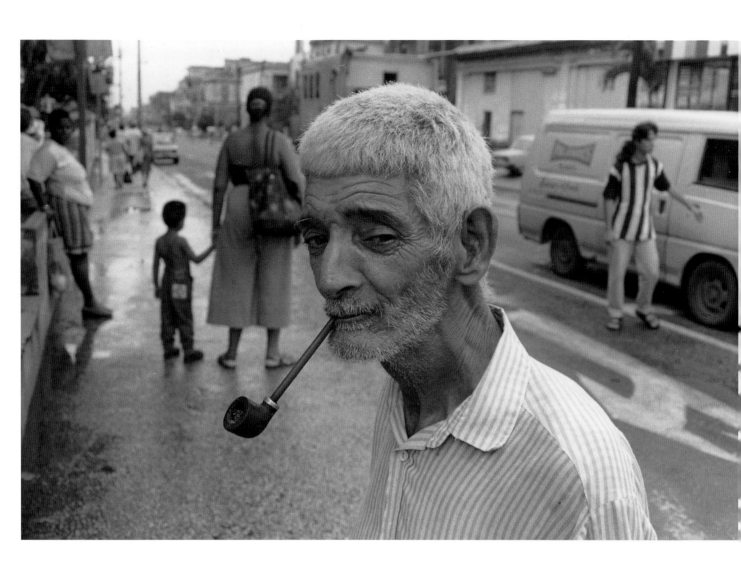

Man with pipe in El Vedado

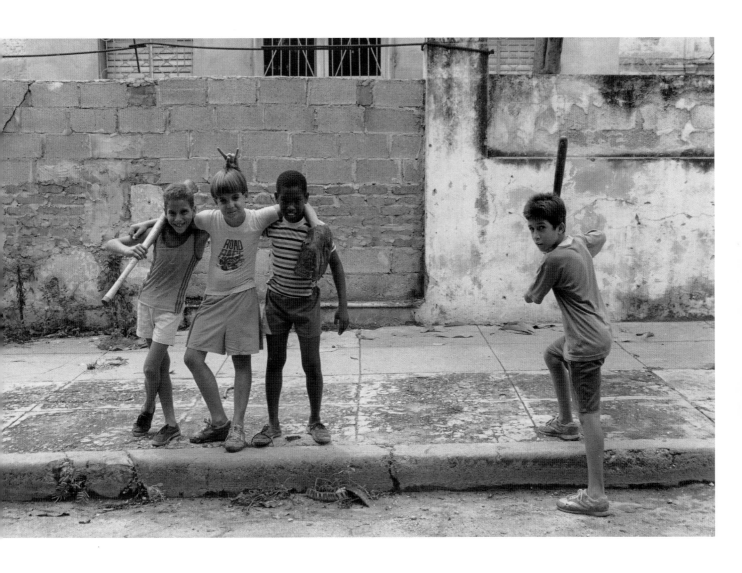

Future baseball stars in Havana

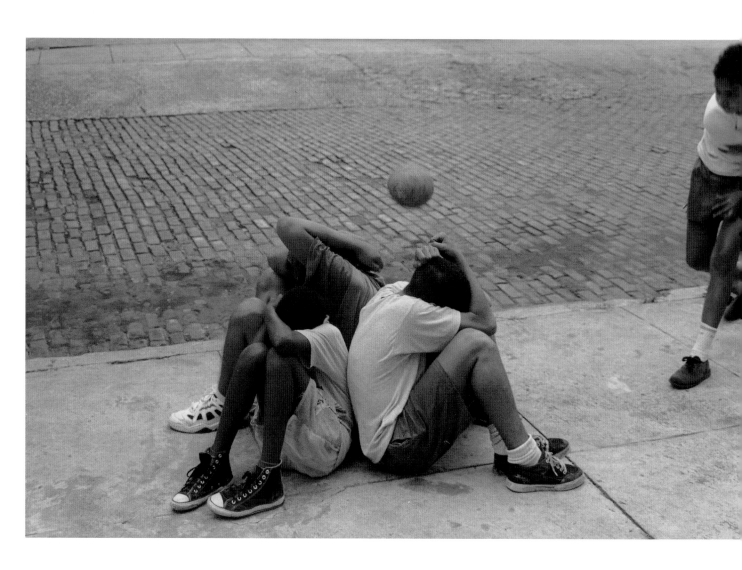

Boys playing game in El Vedado

I was also curious about what the taxi driver said about emigration being economic as opposed to political. I found this excerpt in a December 25, 1993, speech, in which Fidel explains why people leave Cuba:

The first emigrants left the country for political reasons, and many others left for economic reasons. These were people who wanted to go to live in the United States and have a higher standard of living. There are hundreds of millions of people around the world who want the same. The Mexican–U.S. border is crossed by more than one million Mexicans, and there is no socialist revolution in Mexico. . . . Without revolution there would have been no immigration; without revolution, that privilege granted solely to the Cubans would not have been possible. No citizen of any other country in the world can enter the United States illegally and ask for residency. In its hateful war against Cuba, the United States decided that all Cubans who arrived in the country claiming to be political refugees would be authorized to stay in the country. No citizen of any other country has that right. . . . However, all of you know that any lumpen or common criminal, who in any other case would not be authorized legal entry to the United States, is automatically admitted to the country once he gets there in a boat, raft, stolen boat, plane, or whatever. The United States openly encourages this. The United States does not hide that it encourages illegal depar-tures from this country. These illegal departures result in the deaths of many people. The United States does not care if children, women, old people die in the attempt to get to the United States. All they are interested in is publicity, the publicity they create by using the people who reach the United States under those conditions.

Human rights abuses don't get much exposure, if any, in the Cuban press, but every Cuban I talked to was very clear about this: if you are vocal in your opposition to the regime, you end up in jail. It's that simple. Everyone seemed to be aware of the aborted Concilio Cubano meeting, but not surprised. What happened has been amply documented outside Cuba, in particular by Amnesty International, whose information about it I read on the Internet, and information has also been broadcasted into Cuba by Radio Martí. Concilio Cubano, a coalition of 140 nongovernmental groups at odds with the government, including human rights groups, political opposition groups, journalists, lawyers, and trade unionists, was set up in October 1995. A national conference of the Concilio was planned for the weekend of February 24, 1996. The government prevented the meeting by posting guards outside the homes of many members of the coalition to prevent them from going out. They also detained some one hundred people and warned them that they would face imprisonment if they did not stop their activities. The four principal organizers were brought to trial and sentenced to prison terms.

What is truly amazing and instructive about this incident is that when the security forces arrested the dissidents who were going to participate in the meeting, the state was acting "legally." Anyone who dares suggest that socialism has failed, or that maybe something else should be tried, can be put in jail for a term up to fifteen years because the Cuban constitution states in Article 62 that the freedom of expression, association, and reunion "cannot be exercised against the existence and goals of the socialist state, nor against the decision of the Cuban people to construct socialism and communism."

Dissidents who are incarcerated usually get charged with Article 144 of the Penal Code, which prohibits anyone from making statements which "disrespect, insult or abuse the dignity or honor of the authorities." A Cuban who says: "I don't like Fidel's beard—it's too long" can be charged with the "disrespect" rule and legally sentenced to one or more years in prison. Other articles that are used against dissidents and independent journalists are Article 103, which prohibits "enemy propaganda," and Article 143, which criminalizes "resistance to authority." Another article, Article 72, the "Law of Dangerousness," states that individuals can be put in prison for up to four years without having committed a crime if they are considered to have "a special proclivity to commit crimes as demonstrated by behavior that manifestly contradicts the norms of socialist morals." Amnesty International claims that it has received detailed reports of over one hun-

dred cases of imprisonment under the Law of Dangerousness.

What happened to the organizers of the Concilio Cubano? Dr. Leonel Morejón Almagro, the national organizer of the Concilio, was first convicted of "resistance." He was given a six-month prison sentence. The state prosecutor was offended by the light sentence meted out by the judge, and he requested an appeal hearing. The court then added a nine-month term for "disrespect." Lázaro Gonzales, the deputy organizer of the Concilio, was given a fourteen-month sentence in solitary confinement for "resistance." The charge, according to Amnesty International, was "based on allegations that the family took some time to open the door when police went to arrest him." Rafael Solano, who founded the independent news agency Havana Press, was also arrested and charged with "enemy propaganda." He spent six weeks in prison and was offered a choice: leave Cuba or face three years in prison. In May 1996 he left Cuba.

Cuban citizens know about these abuses, and they also know they are being watched by the other institution mentioned by the taxi driver, the CDRs. The Committees for the Defense of the Revolution are basically official government observation posts, one on every block, and in every rural zone, whose job is to keep track of all the residents, observe their behavior, and report back to the authorities any suspicious activity or ostentatious display of wealth that could mean that a citizen might be breaking the law. Outside their

She's mine. Varadero Beach.

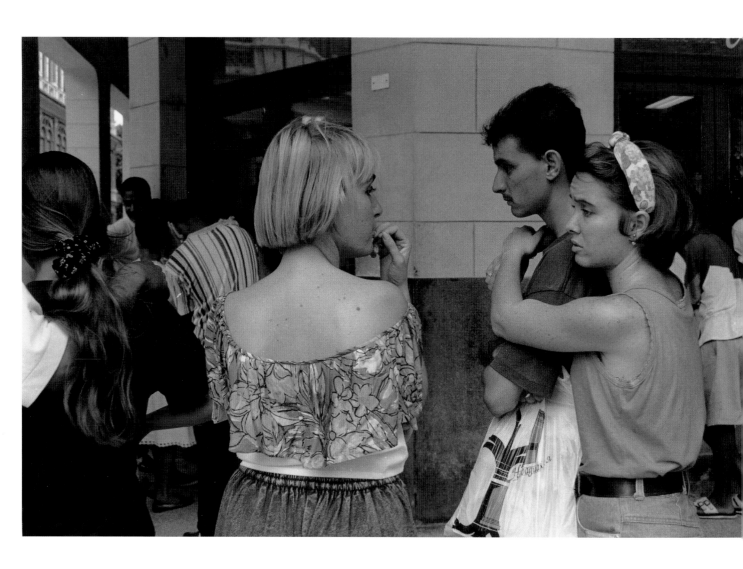

Waiting in line at a dollar store

neighborhoods, Cubans are watched on streets and buses by the Singular System of Vigilance and Protection. At work, they are watched by the government labor union, the CTC, to which all socialist workers must belong. In schools they are watched by the Union of Young Communists and controlled by the universal use of the "Student's Cumulative Dossier." This document registers not only the academic record of the student but also his or her political tendencies and whether the student has participated in the "voluntary" activities organized by the mass organizations, such as harvesting and cutting of sugar cane, and community projects.

Citizens are also watched and infiltrated at work and at play by plainclothes agents from the Ministry of the Interior (MININT). On top of all this, there is a massive police presence. I noticed that there was an armed policeman or military guard posted in virtually every corner of Havana. In addition, canvas-covered trucks full of young soldiers routinely crisscross the city. Another group of plainclothes thugs, the Rapid Response Brigades, are designed to spring into action whenever there is a street disturbance. This is what happened in October 1994 when riots erupted in the port area of Havana. Rapid Response Brigades wielding metal pipes descended on the area and immediately proceeded to beat up and disperse the rioters. According to Amnesty International, up to four hundred rioters were incarcerated. Asked in December 1992 why these units where created, Carlos Aldana, one of the chief

ideologues of the Communist Party responded: "The Revolution cannot survive if an image of armed police firing against the unarmed populace is circulated. But if it's a matter of civilians fighting each other, that is something else." When people outside Cuba wonder why there has not been an uprising in Cuba, I would answer them this way: no one wants to be a martyr and no one wants to end up in a Cuban prison. It's hard to tell how many Cubans are imprisoned, but reports from human rights activists in Cuba claim that there are between 100,000 and 150,000 prisoners in Cuban jails, although most of them are there for economic crimes. There also seems to be an extensive literature from former prisoners now in exile who claim that beatings and other forms of inmate abuse are rampant.

Still, given that all the information outlined above seems to be common knowledge in Cuba, I was surprised how openly everyone I talked to insulted the government. But it's never done carelessly, or in a place where someone else might hear. This incident was typical: A man was fixing an old motorcycle on the sidewalk, on 11th Street in El Vedado. I thought it was an old BMW.

"No way," the man said. "I wish it was a BMW. This is a Russian motorcycle, pure trash. It looks like a BMW, but it breaks down every day. Now I can't fix it; I need a part."

He put away his tools and we started talking. First he wanted to be certain I was who I said I was. Then he told me why.

"The government has an army of undercover

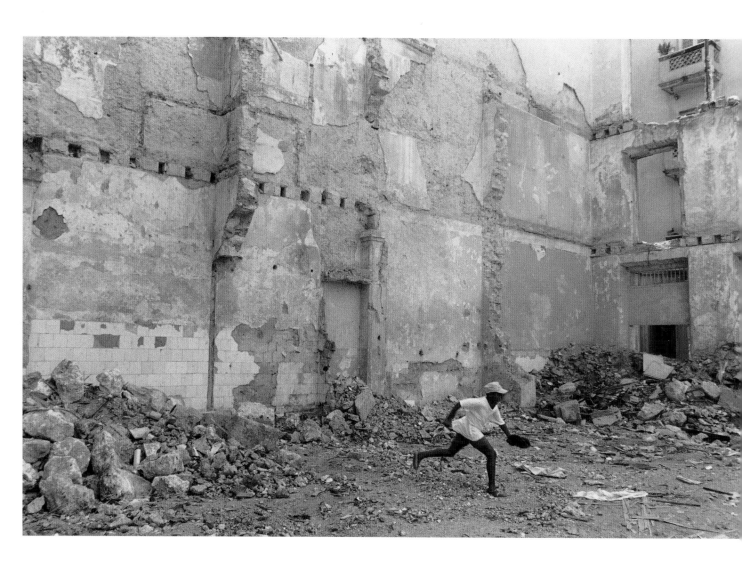

Boy playing baseball in Havana

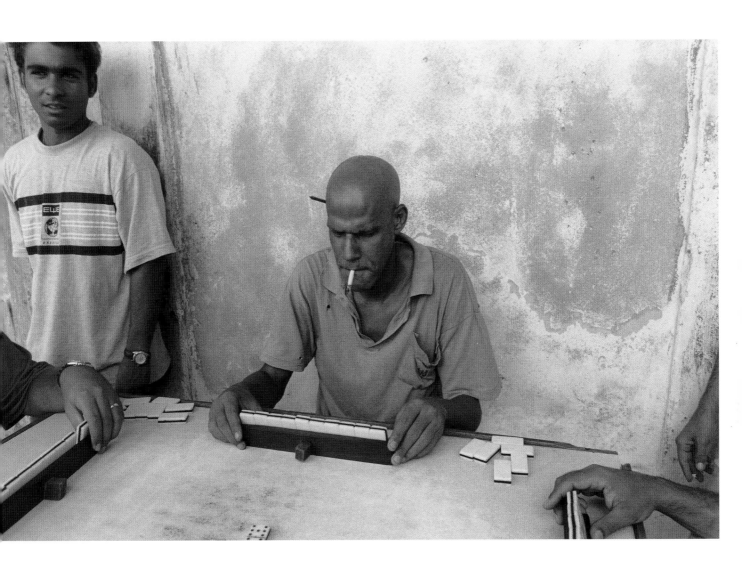

Domino player in Old Havana

agents. They are dressed like you or me, and they are the most vocal antigovernment people around. That's how they draw you in. There are so many agents here that no one knows whom to trust. That is one reason why there is never going to be a rebellion in Cuba. You can't have more than three people plotting without one of them being a government agent. Wait a minute till this citizen passes. She's a hard-core militant."

A young woman walked by us; and then the man started talking again.

"A few years back it was prohibited to talk to foreigners. Now they can't control it because there are too many foreigners. But they don't like it."

"What do you do?"

"Whatever you need, I can do it. I'm a carpenter, an electrician, a mechanic, right now I'm working with a truck. I move people. But to work as a mover I have to pay four hundred pesos a month for the license. They stop me constantly. Yesterday I moved a family from Old Havana to Marianao. We got stopped four times. The state is greedy, they can't tolerate anyone working on their own without taking their cut. But their idea of their cut is virtually all of it."

Another person walked toward us. My new acquaintance stopped talking again. After the person had passed, he said, "I don't know that individual, but just in case. You know, I'm really upset with the Americans. It's their fault Castro is still here making everyone's life in Cuba hell. Time and time again they've saved Castro. You want to know how?"

"Tell me."

"By permitting immigration. In 1980 Cuba was ready to explode. What does the U.S. do? They allow one hundred thousand Marielitos to emigrate. I tell you, those people were ready to kill. So Fidel lets them go. Every time people have been ready to explode the U.S. takes them in. Look, Fidel can do some things well. First of all, he can make fools of the U.S. and kick them in the ass any time he wants, and he gets away with it too. He's outwitted them for thirty-seven years. He's a master at duping the Europeans into thinking that this is a democratic socialist paradise. And he is the master of repression. Nobody knows more about how to effectively repress an entire country than Fidel. But I'll tell you one thing he doesn't know a thing about. He doesn't have a clue how to run the economy. Nobody here can eat. Look around. Look at this city. You'd think he would say: 'O.K. Well, I guess I don't know about this.' But no. He insists. He's convinced he has the answer. We've had thirty-seven years of hell and we are going to have thirty-seven years more. You know what he said in his last speech? He said: 'Today I'm seventy years old, and—guess what?—my vision is still 20-20.'"

It started to rain. I said good-bye to this man and wished him luck. (I developed this habit of wishing everyone luck when I said farewell because I'd started to feel that everyone in Cuba really needed it.) When I got back to my apartment building, I was soaked. It was somewhat dark in the lobby, but I didn't think about it much.

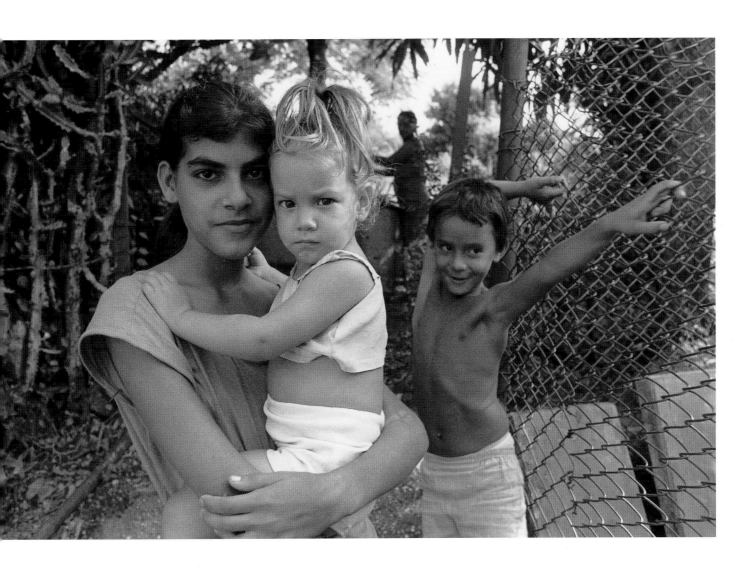

Woman and child in Holguín

I pressed the elevator button. I didn't hear the elevator. I pressed again. From a dark corner of the lobby I heard a soft laugh. It scared me a little. I pressed the button again. Now the laugh got louder; whoever was laughing could not contain himself. A man stepped out from the darkness and said, "Amigo, there's no electricity."

✳

*W*HAT THE MOTORCYCLE MAN SAID about how skillful Fidel is at convincing outsiders that Cuba is a democratic socialist paradise seems to be true among intellectuals. I go to academic cocktail parties, and when other professors hear I'm from Cuba, more often than not I will be told that Cuba now is surely better off than it was before Castro. No one seems to be more surprised by Fidel's popularity abroad than Fidel himself:

The fact that we resist, as Lage has said, is a great deed, not just a deed, but a great deed. You cannot imagine how much Cuba is admired throughout the world! In spite of the U.S. capabilities to spread slander and falsehood, the people of the world feel great sympathy for Cuba! This amazes us! From outside they see better than we, inside, what Cuba has done. How much sympathy, how much admiration, even among the people in the United States!

—FIDEL CASTRO, OCTOBER 4, 1996

I have no doubt, though, that the Cuban Revolution has succeeded in some areas. For one, the Cuban sports machine, as measured by gold medals per capita, is by far the most successful in the world. Education and health care also have to be acknowledged, although they both seem to be suffering in the post-Soviet Special Period. I heard many horror stories in my three weeks in Cuba about the care being offered to Cubans in hospitals, which now lack everything, from aspirins to bedsheets. And while everyone can read, only the government or government-approved authors can write for newspapers, books, radio, and television shows.

I was walking by the Malecón one day when two young Black men sitting on the sea wall asked me where I was from. This sort of question usually meant that the person wanted to talk, and afterward maybe ask for a dollar. But in this instance they really wanted to talk, and specifically, they wanted to know what people got paid in the United States. Both studied architecture. Having once practiced architecture, I could give them a good idea what people earn in that field. Then they told me how badly they wanted to get out and how discouraged they were now that the United States was sending rafters back. They described life in Cuba as intolerable and told me that, mostly, they didn't see a future. I listened, but I was a little restless. I was starting to get a feeling of déjà vu: conversations were beginning to repeat. When they finished I asked them, "I know you have many problems here, but I want

you to tell me what you think is good, what works."

They thought about my question for a while. Finally one said: "The education." And the other one said: "There's no discrimination here."

It is a fact that in Cuba just about everyone graduates from high school and most go on to some professional training. I was amazed by how many professional people I met, even though at the moment, like these two architects, many were unable to practice their professions. The downside is clear: independent and creative thinking is not encouraged (Socialism or Death!), and education and indoctrination seem to go hand in hand. What impressed me the most was how clearly and eloquently Cubans speak. Every person I met had an amazing control of the language. I wonder if it's because of the educational system or simply because of the population's constant exposure to Fidel, who has impressive language skills.

The young would-be architects' other point, the lack of discrimination, is truly palpable in Havana. Interracial couples are extremely common, and I noticed a naturalness between Black and White Cubans which I admired and felt was contagious. Nevertheless, ironies abound. The Cuban leadership is almost exclusively White, and out of a hundred generals in the army, ninety are White, while the majority of Cubans are Black. The prison population is reputed to be overwhelmingly Black.

✳

THERE WAS ONE MIXED GROUP I DIS-covered, about thirty men, who argued out loud every day in plain daylight, in a corner of the Parque Central, the main square in downtown Havana. When I first saw them I was stunned—I thought a few people there were about to kill each other; they were screaming, gesturing wildly, seemingly furious over something important. I assumed they were arguing about politics—what else could unleash such emotions?—and was surprised because it was so public, and in Cuba one does not see public political arguments. I crept closer. They were arguing so fast and furiously that I couldn't understand what they were saying. I crept closer still, until I was at the outer edge of the group. Then I heard the words, Hakim something, Jordan, Pippin. My God! They were arguing about American basketball!

When the basketball argument petered out they started arguing about Cuban baseball. When they found out I was an exile from the United States, they were delighted; they wanted news of American sports, especially baseball. I was a big disappointment, for I didn't know much about baseball, except that the Mets were always in last place. They wanted to know if there was any talk of forming a Dream Team in baseball, drawn from the major leagues. I didn't have a clue. At that point they decided I was either a retard or an impostor—a Cuban who didn't follow baseball—and got back to ignoring me and to arguing

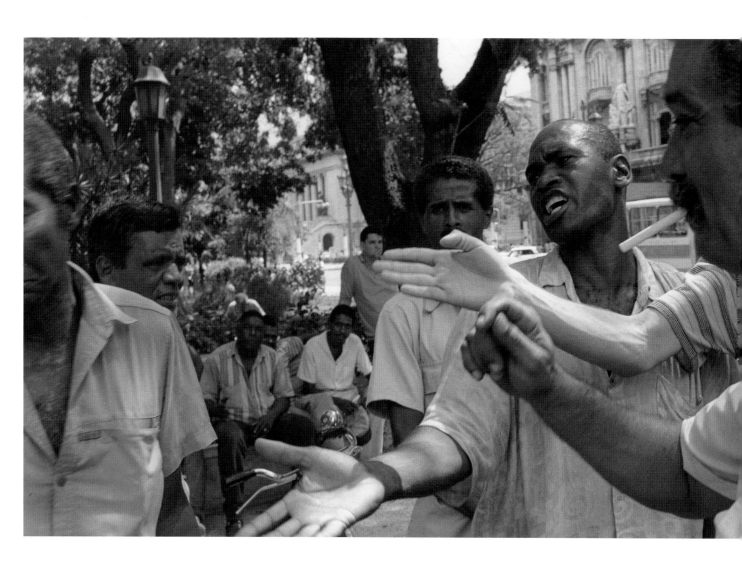

Men arguing about baseball at the
Hot Corner in Havana

whether the Cuban baseball team had a chance against an American Dream Team. This corner was known all over Havana as the Hot Corner. Men meet there every morning and argue about sports all day. What struck me as fascinating was their style of arguing. Arguing is done not just with words but with the entire body—hands, arms, facial expressions, mock anger. It was more like a dance, a performance. I was so fascinated by the visuals at the Hot Corner that I decided I had to bring the video camera and record the proceedings. I came back and for the next few days put hours of sports arguments on tape. The participants didn't seem to mind. I learned later that European film crews have been recording the Hot Corner for years.

<center>✳</center>

I HADN'T USED THE VIDEO CAMERA until I discovered the Hot Corner. I had been nervous about taking it out, after talking to journalists at the *paladar*. What I gathered was that Cuban officials allow tourists and journalists to photograph what they please, as long as you don't photograph military sites, but they are much more concerned when they see foreigners doing film or video. Still, they are tolerant of tourists doing video, but when they see a film or video crew, which signifies a professional production, they immediately ask for credentials. Permission to do film and video in Cuba is tightly controlled, and if you don't have credentials, your equipment can

get confiscated. I see it as a statement about the perceived power of the two mediums: photographs are highly ambiguous; they don't communicate a political message easily. Videos and film are seen as more effective, more dangerous; and the wrong films or videos played abroad can be damaging to the image of the Revolution.

After using the video camera at the Hot Corner, I started to feel more confident. I realized that my one-man video production looked like what tourists do and therefore I was not going to be bothered by Cuban officials. The question then became whether Cubans would be willing to speak about anything politically sensitive with a video camera pointed at them. The answer surprised me. I wandered around the city for a few days holding the camera against my chest and recorded conversations at random. No one I spoke to seemed to care. They all clearly knew they were being recorded but were as frank about their feelings on camera as they had been off camera. When I returned to Ohio I had enough material to put together a thirty-minute video, which combined portions of the sports arguments with the street interviews. The video was shown at the 1998 New York Video Festival at Lincoln Center. What follows are the transcripts of three of the street interviews that appeared in the video.

The first time I wandered off from the Hot Corner with the video camera running, I walked into a shoe repair shop in Old Havana. There were four or five men working in the back and two men seated by the counter. I walked in and

*When it rains, the Hot Corner moves
under the arcade.*

The Hot Corner in Havana

started a conversation by asking one of the men by the counter if this was a state business:

1ST MAN *(smiling): Who else is going to own this? This belongs to Papa. If it was mine I would have a TV and a few young girls attending customers.*

TONY MENDOZA: *But you'd have to work harder.*

1ST MAN: *Yes, but I would earn more.*

TM: *And today, Saturday, you have to work all day?*

2ND MAN: *All day, the same, like any other day.*

TM: *What do you get paid?*

1ST MAN: *The pay, it's down there on the floor. 108 pesos. Yes. I've made 54 pesos for these past two weeks. It's because of politics, which is a disgrace. Here in Cuba you don't earn anything. It's a disgrace. You can put that on TV if you want. I don't care.*

2ND MAN: *How do you explain it, you who are a foreigner? You tell me. I'm from here, but I don't understand.*

TM: *I really don't know the answer. I was hoping you'd explain it to me.*

1ST MAN: *A question. Where are you from? Spain?*

TM: *From the United States.*

1ST MAN: *What salary do you get in the U.S.?*

TM: *Compared to you, much much more. I'm a university art professor. I earn forty thousand dollars a year.*

1ST MAN: *Look at that!*

TM: *But that's a low pay.*

2ND MAN: *Very low, very very low!*

1ST MAN: *But look, it allows you to come to visit Cuba. We cannot be a tourist anywhere. We cannot even go to Camaguey. You have enough to come here. You understand? Why I'm I going to try to save money if I cannot leave here? You can go to Cuba, to anyplace you like. You go to a travel agency and get your ticket. With your salary.*

TM: *Why is the pay so low?*

1ST MAN: *That's a problem of the state.*

2ND MAN: *That's a state problem. Financial problems, you understand.*

TM: *But don't you think you are being exploited somewhat?*

1ST MAN: *To a certain extent, yes. You know why? Because we used to live off the socialist camp. We used to live from the Soviet Union, as a satellite. When they fell, we were left like the orphan in the street, without a mother, and we don't want to deal with you, you who are the real thing. You also exploit, but you also give, you understand? (Turns to the other workers) They exploit you, but they pay you, they make you work day and night, but you earn enough to eat, to live, and to go where you please.*

TM: *I know things are hard here. Someday I hope the man will pass on.*

1ST MAN: *Yes, that's what we hope.*

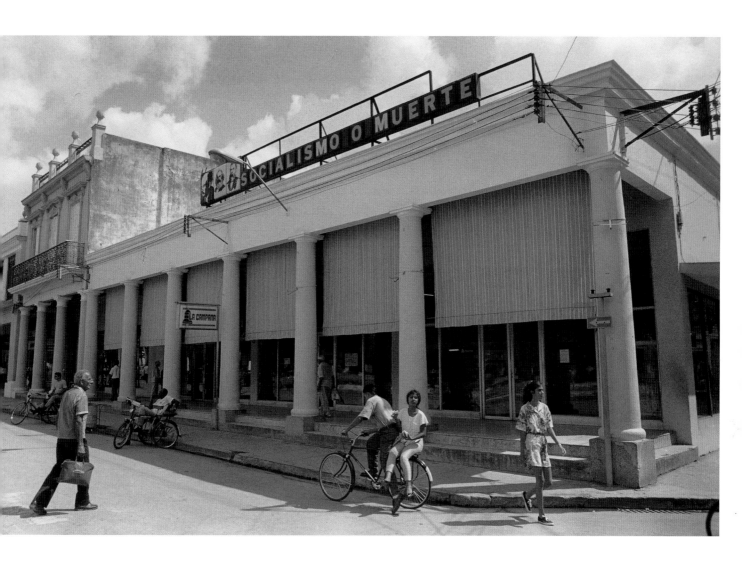

*"Socialism or Death" and images of
Lenin, Marx, and Maceo in Holguín*

Shortly after I left the shoe repair shop, I start talking to a young woman on the sidewalk. I suspected she was a *jinetera,* because she was wearing a gold watch and gold bracelets and earrings and was wearing the black uniform. I invited her to have a *mojito* (a drink made of menthe leaves and rum) in a corner tourist bar, hoping she would tell me about herself on camera. Not very skillfully, I tried to find out what she did for a living. We started talking about Cuban universities:

TM: *What did you study?*

WOMAN: *I studied economics, and I left in the third year. Then I went to modeling school. I've been there three years.*

TM: *Who teaches you?*

WOMAN: *A woman, a lady professor.*

TM: *Who runs it?*

WOMAN: *The state.*

TM: *And where do you model?*

WOMAN: *In the hotels. But they pay only one hundred pesos.*

TM: *How much?*

WOMAN: *One hundred pesos, five dollars a month.*

TM: *That's all the state pays?*

WOMAN: *A piece of shit.*

TM: *What do you do in the hotels?*

WOMAN: *You model clothes, hats.*

TM: *Then you're not talking about going out with the tourists.*

WOMAN: *No, no. For example, I take part in cultural shows exhibiting clothes. I work in a hotel in Holguín. I would like to work in Havana, but here there is too much prostitution.*

TM: *What?*

WOMAN: *Prostitution.*

TM: *But you're not involved in that life?*

WOMAN: *No, I like Havana too much.*

TM: *Are you tempted to get involved in that life?*

WOMAN: *I've thought about it one and a thousand times, but no way.*

TM: *Could you tell me how you see it?*

WOMAN: *What I would like to do is find a man who will allow me to leave here, to leave Cuba. There are too many problems here.*

TM: *Do most young women think like you?*

WOMAN: *All young women go out with tourists, to improve their lives.*

TM: *And Cuban men, are they upset by this situation?*

WOMAN: *The same applies to Cuban men as to Cuban women; they are all doing the same thing.*

TM: *They don't see prostitution as a bad thing?*

WOMAN: *No, nobody sees it as a bad thing.*

The following day I shot some video at the farmers' market in El Vedado. At some point I started talking to a vendor who was selling avocados. He asked me where I was from and I told him.

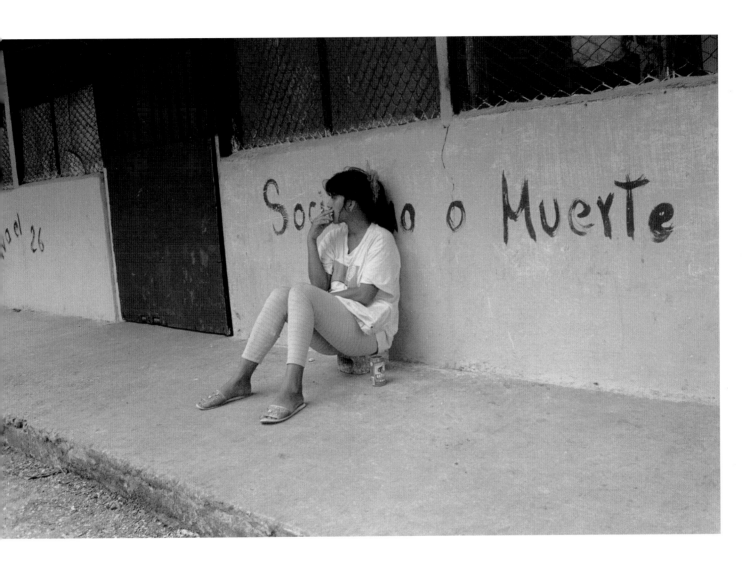

"Socialism or Death"

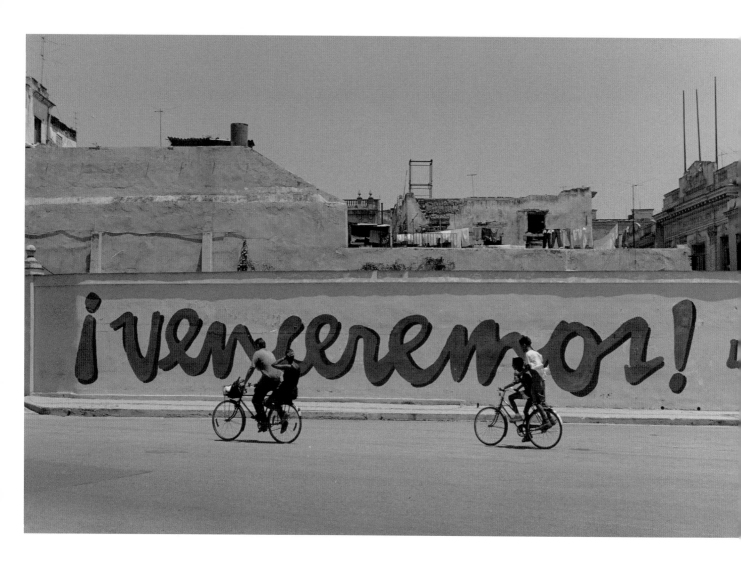

"We will win!"

VENDOR: *Can you get me a visa to go over there?*

TM: *I wouldn't know about that. It's very difficult.*

VENDOR: *(laughing) Look, I'll let anyone sodomize me, as long as they get me out of here.*

TM: *But you are growing some very nice avocados here.*

VENDOR: *(laughing) I'll give them all to you. I'll give them all to you with trees, roots, earth, everything.*

TM: *You know what these big avocados would cost in New York? It is going to bother you a lot.*

VENDOR: *Five dollars!*

TM: *For these, not five, maybe two dollars for an avocado this big.*

VENDOR: *How much do you earn a day, 150 dollars? How much do you earn a day?*

TM: *I'm a university professor.*

VENDOR: *What do you earn a day?*

TM: *They don't pay me by the day. Look, I make the average salary in the U.S., $40,000, which is not enough to live on. By the end of the month, I run out of money, but I do have two kids, and a house and two cars.*

VENDOR: *(with a shocked expression) But that is not enough to live?*

TM: *At the end of the month, I have to use the plastic card, the VISA, to which I owe $23,000.*

VENDOR: *Listen to that. Wait a minute.*

TM: *It's a personal disaster.*

VENDOR: *(He looks for something under his stand.) I'm looking for a rope. And how much do you have to pay for that debt?*

TM: *I pay well over $250 a month.*

VENDOR: *You know how to do it with rope? You don't know how to do it with rope?*

TM: *With rope? What do you mean?*

VENDOR: *So you can hang yourself. (Laughs) If I owed $20,000, I would have hung myself already.*

❋

I CALLED SOME ARCHITECTS WHOSE names were given to me by Miami architects. There is a common interest between some Cuban architects in exile and some Cuban architects in Cuba—saving the architectural jewel which is the historic city of Havana. I was bringing a package of architectural supplies for a group of Cuban architects working on a model of the city, a gift from a well-known Miami architect. I called one of the architects, and he came to pick up the package, mostly model-making supplies: Elmer's glue, Exacto knives, clamps, and a spray paint kit to paint models. The architect took me around Havana and showed me some of the buildings they were hoping to save. He said that around three hundred buildings collapse in Havana every year. We also drove to the other side of the bay, to see a new city the Revolution has built, East Havana. It's a dormitory city for sixty thousand residents, and by any criteria used, an ar-

chitectural disaster. For starters it's very difficult for the people living there to get to their jobs in Havana, because public transportation is terrible, and it's a very long bike ride. The buildings are falling apart because of shoddy construction, and there has been no upkeep. The worst problem is the lack of stores, shops, amenities, parks. Tall buildings were simply laid out side by side, in a barren landscape, endlessly repeated.

When we got back to El Vedado I invited the architect to dinner at the *paladar*. Like the other architects I met, he was very critical of the regime. Architects deal in structures, and he had an interesting structure for analyzing the problems in Cuba.

"The main feature and the main problem of life in Cuba is the lack of options. For example, the simple act of opening the door of the refrigerator. In the rest of the world, one has the option to pick the item you want to eat, whether it's a snack or something you are going to cook for dinner. In Cuba, you open the door and there are no options. You eat what is there. It's usually not what you want. When you turn on the TV, you have no options as to what to watch. There are the Brazilian soaps, the baseball games, and the news. In Cuba the news is like a course in agronomy. There is always a long triumphant feature on a model state farm that is incredibly productive. There are no options when you go to bookstores. It's all socialist-approved literature. In education there is no option as far as what a student wants to study. The state says: These are the careers that we need. You can study this or you can study that, but this year we need you to study this. There are no options where you can live. For example, if I want to live in Santiago, I can't do it. I cannot rent an apartment, nor buy a house, nor get a job in Santiago. I would need a permit from the government to do all that. I would need a job transfer because the government decides where one works, and that is never easy. It is possible to resolve the job question or the housing question if you have a friend here or there, but it isn't easy. The option when it comes to work is: you do what the system gives you, or you don't do anything. If you don't like the pay or the working conditions, the option to strike is prohibited. The supreme lack of options is the statement with which all official speeches are ended in Cuba: Socialism or Death."

"I have a question for you," I said, "which I've asked myself since I've been here. I've heard this joke: 'Socialism or Death. What's the difference?' How come I don't see that scribbled on walls or see the "or" crossed out and an "is" substituted? How come I don't see any antigovernment graffiti?"

"Because we have the most sophisticated repression in the world. Fidel doesn't kill anyone, but if you do something the state doesn't like, you lose your job. And your son and your daughter lose their jobs. If you do something more serious, like actively opposing the state, then they put you in jail. If you do graffiti and they catch you, then you have a tremendous problem. The

Two uses of metal at the Morro Castle

jails are full of people they have caught doing graffiti. We still have plenty of graffiti, but it gets painted over immediately by the MININT or the Young Communists."

"How do you think this is going to end?"

"I have no idea. I hope not violently. The Revolution is already dead. It's a corpse. Nobody here believes in it, but Fidel is not going to be overthrown. By whom? By the citizens? How? From within the government? The secret police not only keeps an eye on the population, they keep an eye on each other and on every government official. For example, every army general is reported on by three spies—a spy from the army, a spy from the MININT, and a political officer. It is impossible to plot an uprising without the government knowing about it. That is what happened to Ochoa. He was executed because he was fingered and then his house was bugged and he got caught bad-mouthing the Castro brothers. Others say that he was planning a plot. In any case he got shot, the greatest Cuban hero of the war in Angola. Cuba reminds me a lot of *1984*, the book by Orwell. Here everything is prohibited. It's prohibited to travel, to write, to speak out, to think. The joke one hears about life in Cuba is that everything is prohibited, and what's not prohibited is illegal."

※

I'D BEEN IN HAVANA FOR ALMOST two weeks, and I was exhausted. I had been walking the streets every day from seven in the morn-

ing to seven in the evening. It's hot in Havana in August, and I would return to the apartment drenched in sweat. I weighed 170 pounds when I left for Cuba, and I came back weighing 150 pounds. I had taken eighty rolls of film, done some video, and felt I had talked to enough people to get a good bearing on the political situation.

What I needed now was a vacation. For years I'd been wanting to correct one of the great mistakes of my youth. I was very ignorant when I was a teenager; the standard wisdom among my group of friends was that Havana was the only worthwhile city in Cuba, and all the other towns were, well, hick towns, unworthy of sophisticates like us. So I knew Havana and I knew Varadero, and that was it. In exile, I'd looked at maps of Cuba countless times and noticed all those small towns by the sea: Cienfuegos, Manzanillo, Guardalavaca, Daiquirí, Trinidad, and other, still smaller towns and beaches, all of them probably beautiful and unspoiled. My plan was to fly to Santiago, Cuba's second largest city, on the eastern end of the island, which I had never seen. From there I would hire a private driver and drive all the way back to Havana, stopping in every town on the map that I had wondered about for so many years.

The trip was a disaster. It started well, however. Santiago is a beautiful colonial city built on a steep hill, with a bay at the base. I spent one day walking around the city and found Santiago's Hot Corner, another group of fiery sport enthusiasts, arguing all day as passionately as the group

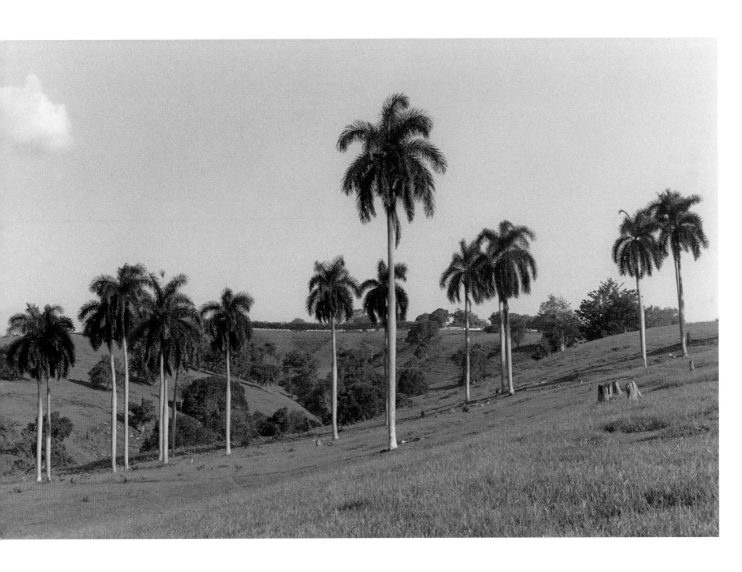

Royal Palm trees at private cattle ranch
in Granma Province

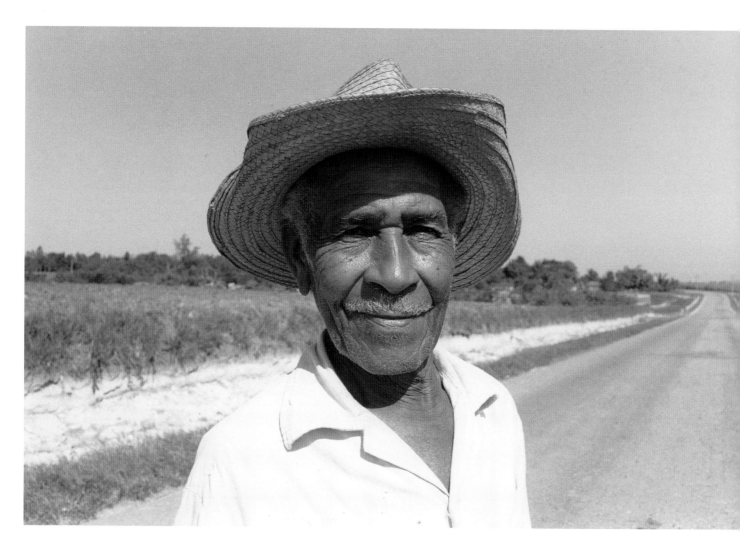

Seventy-eight-year-old peasant in Granma Province.
He walks three miles each morning to tend to his
private plot.

Cattle appreciating the shade

in Havana. They also wanted to hear news about American baseball and were equally disappointed. I found a driver with a Lada and made a one-hour trip to the first beach I wanted to see, Daiquirí, a small and beautiful sandy cove with very clear water and tall mountains rising in the background. On the way to Daiquirí I passed Cuba's weirdest tourist attraction, Parque Baconao, where 250 life-size statues of extremely realistic dinosaurs, skillfully positioned in the landscape, share a huge park with a herd of live goats. I was the only tourist there, and I took quite a few rolls of film. I liked the driver, and he agreed to take me the following morning on my dream tour of the island. He wanted forty dollars a day and gas expenses, a fortune for him and a bargain for me.

We first went to visit a seventy-two-year-old cattlewoman who is related by marriage to a cousin of mine. She runs one of the largest and most successful private cattle ranches in Cuba. When I called her, she said that she would receive me on one condition: she didn't talk about politics. No problem, I said, I was taking a vacation from talking about politics. Later, she explained how the Agrarian Reform Law of 1961 had confiscated most private land in Cuba but permitted ranchers to keep one hundred hectares of land, and her ranch was what she had kept. When she dies, the property will pass to the state. The ranch, two hours northwest of Santiago, was a dream ranch. I've never seen a more beautiful piece of land—lush hilly pastures sprinkled with

royal palm trees, with the tall mountains from the Sierra Maestra range in the background. She took me on a tour of her land in a 1958 jeep, one of three jeeps she owns and keeps in immaculate shape. She breeds show cattle, fine animals which get bought by Cuban state farms and ranchers from South America for breeding purposes. My grandfather on my mother's side had a cattle ranch in Oriente province, and I asked her if she had known him. Of course, she said. My grandfather's bulls and her bulls always competed for the top prize at the cattle fair in Havana. She even remembered Caisimú, my grandfather's prized bull, who always seemed to win the Grand Prize. Caisimú lived in a luxury stable next to the ranch house and was killed and eaten by the revolutionary guards who confiscated my grandfather's ranch when the guards ran out of food.

At the end of the day we had a grand feast, everything grown on the farm, and we left at sundown. My driver suggested we drive to Holguín. One of Cuba's great beaches, Guardalavaca, which I had marked on my map, is one hour north of Holguín. The driver also had relatives with whom we could stay in Holguín. I agreed, and our troubles started. We were driving through a desolate landscape on a terrible road full of gigantic potholes. I hadn't seen a house for a while, when I heard a loud noise, like a shot; a flat. It hadn't occurred to me to ask, but the driver had no spares. Spares are a luxury. It was around nine, very dark, and there was nothing to do but wait for another car to pass. When the first car passed

Daiquirí Beach

Cuba's Jurassic Park in Guantánamo Province

an hour later, my driver got into the car with the tire and asked me to stay with the Lada; otherwise someone would come and steal the battery, the engine, everything, so I stayed. The moonless night seemed incredibly dark, and soon I became aware of many strange noises coming from frogs, crickets, owls, and other creatures I didn't recognize. I'm a coward, I admit it. I started imagining newspaper headlines: Tourist Disappears in Oriente. Body Not Found. I worried for three hours, and finally the driver appeared with a friend and the fixed tire.

We got to Holguín at three in the morning, woke up his relatives, and slept in their living room. The next day we drove to the beach, taking his relatives with us, a man and his wife and their two small children. Normally, when this family goes to the beach, they go on their two bicycles, four hours each way. I loved the beach, but I noticed I was starting to feel a little queasy. On the way back we had the second problem with the car. The engine died. The driver had bought stolen gas from a friend in Guardalavaca, and the gas had been watered down. He had to siphon out all the gas—he had a pail just for this purpose—clean the carburetor, skim the water off from the pail, and put the gas back in. All this took a while, and I was feeling much worse. When we got to the house, I threw up. I had diarrhea and a fever. During the night I had a terrible case of diarrhea, and the house didn't have a normal bathroom. There was an outhouse, which smelled terrible, and I thought I was going to fall in the

hole and die. The next morning I called Mario. He suggested I fly back to Havana; his doctor would see me right away. I went to the airport. The next plane to Havana was sold out, I was told, but I had learned that in Cuba everything is negotiable. I gave the man at the counter twenty dollars, and a seat was immediately found. Back in Havana the doctor told me it was just the water. I had made an effort during my entire stay in Cuba to drink only beer and soft drinks, but while I was in Santiago I had drunk water for the first time.

I spent one day in bed recuperating, and at night I watched TV. I especially enjoyed watching the news, which seemed to follow a predictable formula. The first part was about the triumphs of the Revolution, the middle part featured foreign news, and the last part was the Helms-Burton show. The first part featured a piece on a state farm which was producing a prodigious amount of rice due to a new breakthrough in rice cultivation technology, imported from China, and most importantly, due to the dedication and hard work of the workers, who were all interviewed. The middle part, the international section, focused primarily on the many shortcomings of capitalistic societies, especially those in South America, and another section featured the political chaos, corruption, crime, and poverty that is afflicting capitalist Russia. The Helms-Burton part included testimonials from political leaders in Canada and Europe stating how this awful law was an attempt by the United States to

impose its laws on the rest of the world. Finally there was an interview with a Cuban official, who examined how the blockade was undermining Cuba's economic efforts.

The really popular program followed the news: *Women of Sand,* a Brazilian soap. Walking down the streets of Havana between 9:00 PM and 10:00 PM is a very eerie experience. There is no one on the streets. In every window one can see a blue pulsating glow, the light from the televisions. What's wonderfully surreal is that all the windows are pulsating identically, as if the city were one living organism; everyone is tuned in to *Women of Sand.* The plot revolves around two upper-class women who are identical twins—a very good one and a very bad one. The bad one is dedicated to making the life of the good one miserable. She impersonates the good one and makes a mess of things. A typical soap, without any socialist redeeming values.

❋

A FEW DAYS LATER I WENT ON A DAY trip to Varadero Beach, to see the beach house where I had spent my first eighteen summers. I've thought about that house, and those childhood summers, more times than I care to admit. I can't imagine a better deal for a child—spending summers on a house situated next to a tropical ocean, on a beach with the finest and whitest sand and crystalline clear water, teeming with fish. In those days, I loved mornings. I slept with my bathing suit on, and at six I sprang out of bed, went up to the porch, and checked out the ocean. If it was calm I could expect a group of cousins to show up shortly at our porch, and off we'd go in our outboard, hoping to catch the biggest grouper anyone had ever caught in Varadero Beach. When I turned twelve I discovered spear fishing, and a few years later, girls. That beach set me up for life: every day was a joyous romp, an adventure. That's what I remember. Now I can't help observing that I don't spring out of bed that way anymore.

The house was in a residential area called Kawama, which used to be the favorite summer address of wealthy Cuban families during the fifties. One hundred large summer homes had been built side by side on this thin strip of land, with the Caribbean on one side and a lagoon on the other. The houses are still there, in various states of disrepair. I was walking on the bicycle path next to the lagoon, taking pictures of the houses where many of my friends and relatives had lived—my uncle's house, my best friend's house, the house where the first girl I fell in love with lived. I remembered getting up early, at five, and hiding in the dense foliage under her window, like a thief, where my purpose was simply to be near her and imagine her sleeping in her bed, and all the while I was getting bitten by mosquitoes. The path I was walking on also brought back memories, of evening walks on clear nights when every star in the Milky Way seemed visible, surrounded by the call of crickets and

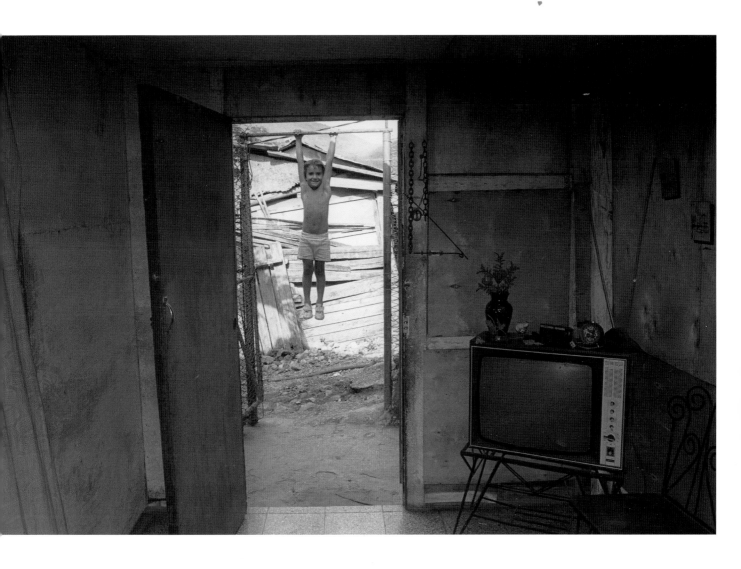

House where I stayed in Holguín

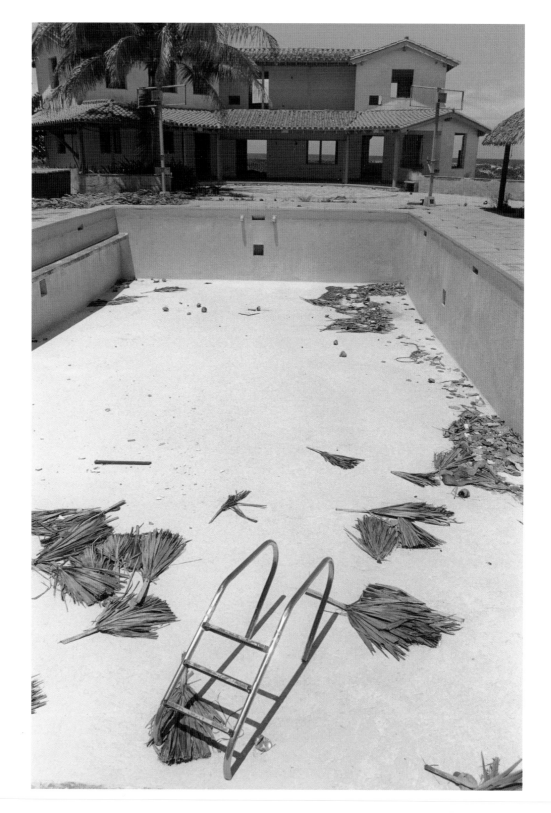

frogs and the constant rustling of the fronds of the coconut trees.

The closer I got to my family's house, the more I expected to see a ruin. Almost all the houses I was passing were gutted, although some were being restored. For years, the Revolution sent the best scholarship students to this area to enjoy the beach every summer, and apparently, scholarship students destroy houses. I finally reached my family's house, and again I was pleasantly surprised: it had been perfectly maintained or restored. As I approached the house I could hear someone inside playing an instrument. The front door was open. I went in and walked up the broad stairs that opened to the central court. A young woman was playing the saxophone on the porch overlooking the ocean. Her eyes were closed. I liked the scene, and I also liked the melody of the song she was playing. The exact spot that I had considered paradise was now another artist's paradise, and that felt good. I couldn't help myself; I crept closer to her and took a few pictures before she opened her eyes and found me there.

The house was a government guest house. The sax player was a member of an all-women band, guests in the house. The porch had a delicious breeze flowing through it, and I was amazed to find the tonalities of the ocean exactly as I remembered them: clear water with a white sand

*Gutted summer house in the
Kawama section of Varadero Beach*

bottom for the first hundred yards, then a patterned strip of dark—the rocky area were I used to snorkel—then another short strip of white sand bottom before the water color turned to a deep blue. I looked at the ocean for a while, as I had done every morning when I was a child, and wondered if what I had heard was true—that the ocean near the shore was fished-out, due to the food crisis.

The sax player offered to take me on a tour of the house. It was strange seeing my parents' room, my room, my grandparents' room. Every room brought forth memories, small incidents, family ghosts walking around, still laughing from a joke or their good fortune. After a while I knew I had to do this: I went down to the sand, left my clothes on a pile with the camera on top, and dove in. I stayed in the water for an hour, looking toward the house, trying to remember those days when I was young and overflowing with optimism and confidence. In those days this was a busy beach; young kids splashed in the water, teenagers flirted and water-skied. Ladies wearing huge straw hats stood in circles in chest-deep water, exchanging stories about their friends and children. When I closed my eyes, I could almost hear the screams of the kids and the whine of the motorboats. But when I opened them I could see that the beach was empty. The sand didn't appear as fine nor as white. The del Valle house, which used to be next to ours, had disappeared. All that was left there was a huge sand dune. The other nearby houses were gutted, including my best friend's house. The

*The porch where I used to nap at my family's
former summer house in Varadero Beach*

one redeeming detail in this scene was another wonderfully sorrowful melody coming from the sax player, who continued to play with her eyes closed on what used to be our porch.

✳

BEFORE I LEFT CUBA I HAD A CONVERsation with Paquita, a woman who I had been told strongly supported the Revolution. She was the niece of Manuela, the nanny who raised my three sisters and lived a large part of her adult life with my family. Manuela had immigrated to Cuba in the 1930s from Galicia, an impoverished region in Spain. She married a Cuban man and had a daughter, but in short order, her husband and her daughter died of malaria. She told us she took the job as a nanny for Margarita, my older sister, because Margarita's curly blond hair reminded her of her daughter. She lived with my family for the next twenty years. When we left she stayed behind. One of my younger sisters had visited Manuela in Cuba, just before Manuela died, and had met Paquita and her husband. Both were solid militants, and both were professors at the University of Habana. My sister had sent with me some money for Paquita. I called them, and they came over. I was eager to meet them and also find out how Cuban university professors practice their profession in a censored land.

We talked for a while about my family, my sisters, and Manuela, and then we moved into politics. I told them that as an artist I had always been disturbed by Fidel's famous statement, which he made at a meeting of writers and artists in 1961, where he laid out the guidelines for what would be permissible: "With the Revolution, everything. Against the Revolution, nothing." I observed that artists have historically functioned as critics of the status quo. Did the people at the university, especially those in the arts, see any kind of problem with Fidel's guidelines?

"No," Paquita said. She would do all the talking.

"Why not?"

"Because we are realists. The Revolution has a very powerful enemy ninety miles from our shore, and the enemy has many agents and sympathizers within our country. We can't allow our enemies to attack us with impunity. We have a right to defend ourselves. We won't allow our enemies to hold a forum, unmolested. We want this project to continue."

"What project are you talking about?"

"Socialism. The Cuban Revolution. It's a beautiful project."

"Still, if the project is that good, shouldn't it be able to withstand some criticism, some opposing positions? As an artist and a writer I would find it very difficult to be told how I should think and what I can't criticize. Frankly, I would find it impossible to live here. You are, in effect, eliminating artists."

"One can criticize here. We allow criticism. What we don't allow is counterrevolutionaries, people who intend to destroy the state. People

say whatever they want, in the bus, in the street. I take the bus every day and I hear people complaining about everything, about the government. That's their right."

"Yes, but can they complain about the government on television, or in the press?"

"Well, not there."

"Why not?"

"We have a different system here. We believe in fomenting solidarity, or nothing will get accomplished. We don't believe in the chaos of the multiparty system. Look what the multiparty system has accomplished for South America. Even though this is a beautiful project, it has its problems, and we welcome constructive criticism, but we don't want anyone to tear it down. That's not constructive. What we want to do is fix it."

I let that go and brought up some questions I had about the self-employed workers. I mentioned that I felt they were being abused by the government, whose long lists of excessive restrictions and fees seemed designed to drive them out of business. The way I saw it, if the *paladar* owner does well, everyone around him benefits. The man who repairs his refrigerator benefits, the fisherman who brings him the fish benefits, and so on. Why was the government so afraid of the *paladar* owner succeeding?

"The answer is very simple. If the *paladar* owner doesn't have restrictions, he will become very rich. This is a socialist state. We do not permit inequalities. We do not have rich people here. Our government has the right to tax the people,

just as your government taxes the people. With those taxes we pay for health care and education, just as you do."

"But when you legalized dollars in 1993, you accepted inequalities. A taxi driver still earns in a few hours what a socialist doctor earns in a month. Not to mention the unequal benefits of high government officials."

"The taxi drivers are examples of inequalities we want to eliminate. We had to allow self-employment because of the unemployment caused by the fall of the Soviet Union. Now we are trying to reduce the inequalities by taxing self-employed workers. We are not rushing wildly into private enterprise, because we're aware that it brings many problems and is something new for us. It has to be studied, done slowly, little by little. We can't jump wildly into something in which we have little experience."

"Can I be really blunt, Paquita, and tell you what I see happening here?"

"Go ahead."

"You've had thirty-seven years of one system, socialism, and it's clear it doesn't work. My argument is simple. The Cuban economy has never worked, a fact that was made evident when the subsidies stopped. Very little gets produced, and Cuban citizens don't earn enough to eat. The city of Havana is crumbling, as we speak. I walk the streets every day, and I only hear complaints. All this after the Soviets handed you billions of dollars to improve the economy. Socialism has failed in Cuba as it has failed everywhere on this planet.

That is a historical fact. And those who attempt to criticize this obviously failed system, like the leaders of the Concilio, get put in jail. Do you ever wonder if you might be on the wrong path?"

"No, because I don't think we've failed. That's your interpretation."

There was an uncomfortable silence. Paquita and her husband left shortly afterward. I had just flunked interview school.

I couldn't help marveling at the many ironies involved in our meeting. We were both professors. I became one partly because I had a privileged education: Choate-Yale-Harvard. Paquita had became a professor because the Revolution had made it possible for Cubans from a humble background to gain access to education. It probably would not have happened in the old days. Yet the same Revolution also seemed to have no qualms about repressing and starving Cuban citizens with other set-in-stone political and economic policies that have failed in Cuba, and in fact in every country that has tried them, and that are no longer supported by ordinary Cuban citizens. As far as I could tell, there are very few Paquitas in Cuba, and I suspect most of them have privileged positions.

✳

DURING THE LAST WEEK I WAS IN CUBA I asked many of the people I had met: How did they see the future for Cuba? What would they like to see happen?

Mario told me right away that I was going to get a lot of blank stares because Cubans have been conditioned to think of the future as the next three days—what are they going to do today, tomorrow, and maybe, if they are futurists, the day after tomorrow. But most people with whom I talked had opinions. They were not optimistic. Everyone noted that Castro is quick to say in speeches that "revolutionaries never retire." And I didn't find one person in Cuba who thought that Castro could be overthrown by force. What are the Cuban citizens going to do—throw mangos at the Cuban army, at the Cuban police? It's worth noting that in his speeches Castro has wholeheartedly supported the Chinese government's action in Tiananmen Square, and no one doubts that he will use force against the Cuban people if he has to. The Ochoa execution served as a warning as to how Castro reacts when he feels threatened. If Ochoa, the greatest Cuban hero of the war in Angola, can be summarily executed, then no one is safe. Even if an internal coup or an external rebellion were possible, such a rebellion would have to have a leader, and the Cuban penal code makes it easy for the state to incarcerate any potential opponent. There are no Lech Walesas in Cuba. If there were, he or she would be immediately charged with "disrespect" and put in jail or sent into exile, which is exactly what has happened.

What if Castro were to die? What then, I would ask. No one had an answer to that question, but most agreed that Fidel is the only per-

son in Cuba who can keep Cuban socialism from disintegrating. Not one person showed any enthusiasm for Castro's assigned heir—Raul, Fidel's brother, who is considered the henchman of the Revolution. Nor were they enthused by any of the bright younger cadres around Fidel, like Roberto Robaina, who promises more of the same. Would they trust someone from Miami? Cubans in the island seem distrustful of the Miami Cubans. This struck me as peculiar, since from the moment I landed from Miami, I was treated wonderfully by everyone I met. It's clear, though, that the government has done an excellent job of instilling fear of the exiles by suggesting that if the Revolution were to fall, Cuba would suffer a fate even worse than the economic and political chaos that afflicts the former Soviet Union. There would be a returning horde of greedy exiles, bent on revenge, gleefully throwing everyone out into the streets after reclaiming every house and apartment in Havana. This scenario is not likely. Even the ultraconservative Cuban American National Foundation has stated that it does not favor a repossession of the housing, but still the fear of losing their homes strikes a powerful chord among Cubans. Cuban citizens have very little. They don't have political freedom, they don't have jobs that pay, they don't have savings, they don't have possessions, and now they don't even have acceptable health care or education. The only thing they have is their (crumbling) home or apartment, and they can't bear the thought of losing that. And the government never misses a chance to remind the public what awaits them if the Revolution were to collapse:

The regime that the U.S. government wants to impose on us is fully incompatible with the social achievements since 1959. Our work would be completely destroyed. It would be liquidated in the most violent manner, because what predominates throughout the world today is a form of capitalism that some of its defenders have openly qualified as savage. Moreover, in the case of Cuba, the imposition of such a regime would signify the triumph of the most aggressive and reactionary sector of U.S. society, those with a visceral hatred for us, whose tools are the Mafia of annexationists and Batista supporters who demand, in the language of Hitler, a three-day license to kill after the fall of the Revolution.

—DRAFT VERSION OF THE DECLARATION OF THE FIFTH CONGRESS OF THE COMMUNIST PARTY OF CUBA (OCTOBER 1997)

What do Cubans think about the embargo? Do they think the "cruel and immoral blockade," as Castro calls it, is the culprit of all of Cuba's economic problems? Curiously, I didn't find many Cubans who were eager to talk about the embargo, or blame it for Cuba's problems. A visit to a dollar store makes it clear to everyone that the embargo doesn't prevent Cuba from acquiring whatever American products Cuba wants or

Park bench in Havana

needs, since they can get them fairly easily through Panama or Mexico. The embargo certainly doesn't prevent Cuba from selling its sugar and other products to the rest of the world, provided it produces the sugar and the other products, nor does it prevent Cuba from buying whatever it needs from the rest of the world, provided Cuba has the dollars. I think everyone knows what is the cause of Cuba's economic problems: an economic system that doesn't work and jobs that don't pay. Why would anyone work fifty hours a week cutting sugarcane, under an unbearable tropical sun, for ten dollars a month when the same amount can be earned in an hour or two driving a taxi or tending bar at a seaside resort? Apparently, very few people are willing to cut the cane or do whatever else the government wants done in exchange for socialist wages in pesos. Walking around Havana I saw many men sitting around, playing dominoes, talking, arguing about sports, and doing very little work. Why work? There was a time when socialist idealism motivated workers, but that time is long past.

My guess is that very few Cubans believe Fidel when he says, as he did in a December 23, 1995, speech: "If the blockade disappeared, we could also join the bloc of countries with high growth rates." Cubans are aware that for the past thirty-eight years the government has put the blame for its economic problems on a million different reasons, including the embargo, but the bottom line is that the problems persist, and after nearly four decades of the Revolution and four decades of constant sacrifices, the economic problems are not getting solved—they are clearly getting worse. As the man with the Russian motorcycle said, Castro has conclusively proven one thing to Cubans—that he is no economist.

And what about the Helms-Burton law, which penalizes foreign companies which trade with Cuba? Will it force Fidel to change his ways? Every Cuban I spoke to ridicules the idea that the Helms-Burton law will force Fidel to change anything. They will tell you that Fidel is intellectually and emotionally incapable of complying with any U.S. demand. He has built a persona which denounces, automatically, everything the United States wants or does, so capitulating now to his lifelong enemy is a laughable and totally unthinkable outcome—like a fish renouncing water. In recent speeches Castro has gone as far as to say that the greatest accomplishment of the Cuban Revolution is not health care or education, baseball or music; the greatest accomplishment is that it has always said no to the United States:

If there is one thing we can say today, it is that the greatest accomplishment the Cuban people have been able to achieve above all other nations in the history of the world is that we have been able to challenge the empire. We have been able to resist that empire for thirty-five years. The empire already knows we are defending values that are very sacred, and we are defending hopes we will never renounce—

Park bench in Havana

hopes for which we revolutionaries are willing to go to our graves.

And what are the chances that Fidel would agree to free elections, another requirement of the Helms-Burton law? Fidel considers this requirement to be, among other things, *garbage*. This excerpt from his July 26, 1988, speech is typical:

And I must say here once and for all that we do not need more than the party—just as Martí did not need more than the party—to carry out the struggle for Cuba's independence. [applause] Lenin, likewise, did not need more than the party to carry out the October Revolution. Those who believe that we are going to allow small parties to organize counterrevolutionaries, pro-Yankees, and the bourgeoisie in Cuba should not entertain any such hope. No! There is only one party here, the party of our proletarians, peasants, students, workers, and our entire people. [applause] This is the party we have and will have. I hope that when we celebrate the seventieth anniversary and the centennial, history will prove that we do not need capitalist political formulas. They are complete garbage, they are worthless, they constitute unending political deceit.

If anything, after the fall of the Soviet bloc, Fidel has now found a new cause. Initially, he saw himself as the liberator of the oppressed in Cuba, and then as the liberator of the oppressed in Latin America. When he sent his troops to Africa, he saw himself as the liberator of the oppressed everywhere. But with the Soviets out of the picture, and no available funds for internationalist adventures, he now proclaims that Cuba is turning a new and glorious page in history—entrusted with the sacred duty of not only keeping the flame of Marxism-Leninism alive but also remaining the main opponent of the evil empire:

Our nation's prestige is immense; we really are—and these are not just words—the hope of millions, or perhaps even billions of people throughout the world who hate and repudiate this unipolar world, in which the powerful United States hides its presumed ownership of the world less and less.

—FIDEL CASTRO, MARCH 15, 1997

※

THE MAIN ACCOMPLISHMENT OF THE Helms-Burton law has been to provide Castro with the perfect excuse for a failing economy. The rest of the world seems to have bought that explanation, especially the Canadians, Mexicans, and Europeans, who also see Helms-Burton as an infringement of their rights and have gone out of their way to increase diplomatic contacts, trade, and investment on the island. I asked the economist I met at the *paladar,* who struck me as the

Park bench in Havana

most clear and eloquent critic of the government I met in Cuba, for his opinion on Helms-Burton, and he had this to say:

"What really worried Fidel was that Clinton was not going to pass the Helms-Burton law. The law that really scared him was the 1992 Torricelli law. He feared the provisions in that law which called for the U.S. to support individuals and organizations in Cuba to promote nonviolent democratic change in Cuba, what's been called the Track II provisions. The U.S. was going to start funding the independent groups here, the independent journalists, the church, the dissidents, groups like Concilio, and they planned to flood the island with U.S. delegations of college professors, intellectuals, artists. Fidel was worried because the dissidents were getting stronger, the church was getting stronger, the independent journalists were getting their antigovernment views published outside Cuba, and Concilio had called for a conference of all its member organizations in late February. What was Fidel's response? Just before the Concilio meeting Fidel shot down the Brothers to the Rescue, and of course, the Helms-Burton bill was passed almost immediately. With the excuse that we were under siege, he arrested the Concilio people, the independent journalists, and cracked down on all the government functionaries who were talking about establishing a dialogue with the exiles and the U.S government. Most importantly, Helms-Burton effectively scuttled the Track II programs, which were his real concern. Once more, as he has done so many times in the past, Fidel outmaneuvered the Americans."

That explanation sounded as good as any I've heard as to why the planes were shot down, and Castro has proven that his gamble succeeded. The Concilio has been destroyed, the independent journalists are in jail or in exile or under constant harassment, the Europeans and the Mexicans and much of the rest of the world have rallied in support of Cuba and against Helms-Burton, with the Canadian prime minister almost immediately going down to Cuba to embrace Castro as a long-lost friend.

"If you were the U.S. president," I asked the economist, "what would you do?"

"I would do exactly the opposite. I would try to get rid of the embargo, which might be politically impossible to do, but that's what I would try to do. The embargo provides Fidel with his last excuse why the Cuban economy is in shambles. Also, Fidel functions best when he is attacked. He becomes energized. He needs an enemy. He needs a scapegoat, and the Helms-Burton law is made to order. The image of America, the most powerful country in the world, flaunting international laws, trying as hard as it can to squash little Cuba, is still a powerful image that works in favor of Castro, especially internationally. No. The way to fight Fidel is not on a frontal attack. The way to fight him is to hit him where his system is vulnerable. Flood Cuba with American tourists, flood Cuba with dollars, flood Cuba with ideas and information. The socialist state cannot

withstand that. That has been proven throughout the world."

What the economist said makes sense to me. The goal of the hard-line policy—of the embargo, of isolating Cuba—is to bring down Fidel Castro and socialism, and, obviously, that policy has failed. Presumably, the idea behind the embargo (and the 1992 Torricelli law, which tightened the embargo, and the 1996 Helms-Burton law, which tightened it even more by penalizing foreign companies that trade with Cuba) is to apply enough economic pressure so that the Cuban economy gets so bad that the public will rant and rave, riot, and rebel, and force Castro to capitulate or hold free elections, at which point the Helms-Burton law would allow the embargo to be lifted. This is what many Miami Cubans hoped would be the outcome of a real tough embargo, and what Jesse Helms thought would happen when he said after the Helms-Burton law was passed: "Now we can say, adiós, Fidel."

It should be obvious to everyone that more tightening of the screws won't bring down Castro. In 1994, when the full impact of the fall of the Soviet Union hit Cuba, when the subsidies reached level zero and the Cuban economy hit rock bottom, when everyone in Cuba was hungry and cats in Havana were running for their lives, when there was no electricity or gasoline and one dollar brought one hundred pesos (which meant that the average Cuban was getting paid two dollars a month), in short, when the economy reverted to levels not seen since the eighteenth century,

Castro didn't fall. Why? Every Cuban in Cuba knows why: because the repressive system remained intact, because Cuban prisons have a terrible reputation.

I got the distinct impression that Cubans on the island don't need further deprivations nor further convincing that socialism has been a failure. I don't claim to have done a scientific survey, but I counted the people I encountered who supported the revolution with the fingers on one hand. Why would anyone in Cuba support Castro? Imagine this scenario. Let's say that after Watergate, Richard Nixon had decided not to resign but instead, through strong-man tactics, had remained in power for thirty-eight years. In the course of his rule, he abolished all political parties, eliminated the free press, and allowed only one newspaper, the *Nixon Times*, to be published. The free enterprise system was declared to be inhuman and intolerable, and all businesses, large and small, were confiscated by the government. Any American who protested Nixon's policies was declared a criminal and put instantly in prison. In the meantime, 45 million Americans fled through treacherous mine fields to Mexico and Canada. Many exploded trying to escape. Moreover, during the thirty-eight Years of Nixon, his economic policies were so disastrous that the salary and buying power of the average American went down by a factor of twenty. Through it all, TV programming on the two government stations was often canceled, supplanted by yet another Nixon six-hour TV speech, on the topic of the

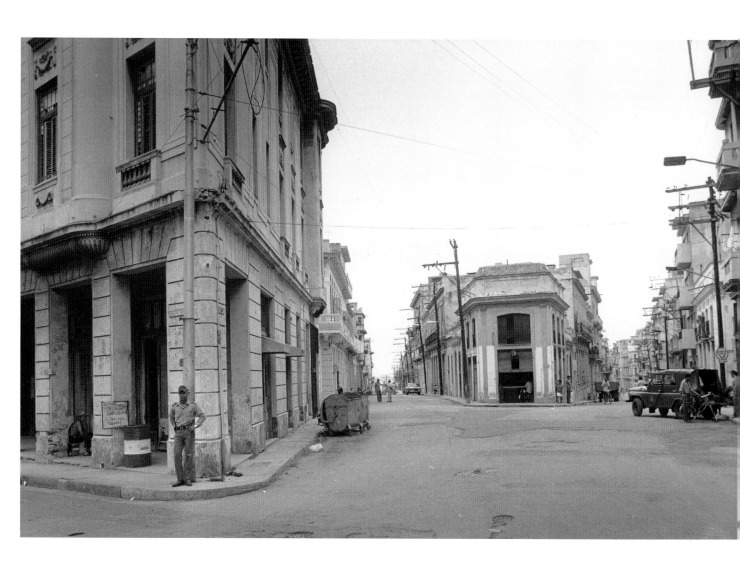

Guard at a corner in Havana

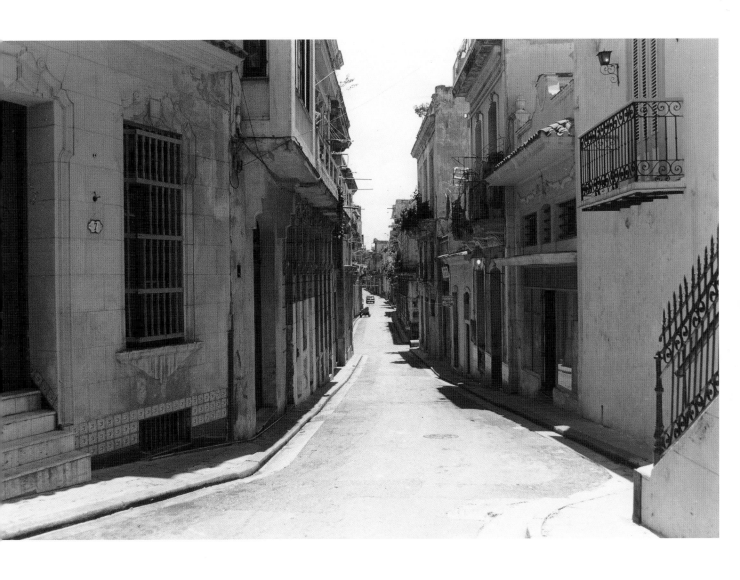

Noon street scene in Old Havana

righteousness and the brilliance of his policies. How many Americans, after thirty-eight years of this scenario, would still support Nixon—10 percent, 5 percent, 1 percent? Anyone? A scenario not unlike this has played out in Cuba.

The most vital and rabid antiCastro Cubans I found in Cuba were the self-employed workers. This segment is fomenting economic growth, it's promoting capitalism, it's promoting entrepreneurs, it's promoting political independence; in short, self-employed workers are paving the way for the transition to a market economy and a democratic government that most people outside and inside Cuba seem to want. Who is supporting these independent Cubans? Not the Helms-Burton law, which is doing everything it can to squash them. These independent Cubans are supported by Canadian tourists, by Italian tourists, who leave their dollars in Havana and make it possible for the *paladar* owners and the other self-employed workers to stay in business. The *paladar* owners pay for services from the other independent workers: the man who brings him the fish, the man who repairs his refrigerator. These workers in turn support others. None of these people will ever again work for the miserable peso wages paid by the government or go to the plaza to listen to Fidel. If their numbers increase and their wealth increases, another space other than the official socialistic space will start to develop and prosper. It seems to me that the United States should be doing what it can to support these people. One simple way to do this is by eliminating the travel restrictions to Cuba. Let Americans travel to Cuba; let them go down to Havana with their video cameras and their Hawaiian shirts and their different thoughts and opinions and, especially, their dollars. It's a fact that Fidel has repeatedly acknowledged in his speeches: the more dollars that are put in play in Cuba, the more problems that are created for Cuban socialism.

A humanitarian case can also be made for ending the embargo. I was appalled by what I saw in Cuba. When you walk the streets you see faces that are as devastated as the buildings. People look depressed, beaten down. They stare into the distance in a trance, as they wait for buses, in endless food lines, or when they sit on the seawall, intently staring toward the horizon, toward Miami. All conversations in Cuba ultimately have to deal with "the situation." How is dinner going to be procured tonight, or tomorrow night? No other thoughts or concerns are possible. It's limiting and depressing. The liveliness, wit, and energy that I have always associated with Cubans miraculously survive, in bits and spurts, but it's a struggle. Decades of Revolution, of adversity, of lines, of rationing, of repression, of intransigence, have left their mark.

In addition, as a *New York Times* editorial succinctly stated on August 4, 1998, the embargo "runs counter to a theme of American foreign policy today, namely that increased trade and investment can be a useful mechanism for encouraging democratic change." Communist China, which commits worse human rights violations

than Cuba, clearly benefits from that theme. Why is Cuba the lone exception to the dominant theme of U.S. foreign policy?

The answer, I think, is that the level of passion, of antagonism, of outright hatred that one finds on both sides of the Florida Straits has gone off the charts. The Miami exiles can't forget the suffering and humiliations they've endured, and they can't forgive Castro and the Cubans who stayed behind and at some point supported the regime. And Castro has been relentless in his insults to the exiles and his attempts to humiliate the U.S. government. U.S. policy, in the meanwhile, has been steadfast in its attempt to isolate Castro and to hurt Cuba economically. The end results are that the Cubans in Cuba are eating cats and no one is thinking rationally when it comes to Cuba policy.

The problem will continue to be that there has not been a large enough constituency for an approach to Cuba other than the hard-line approach. Miami Cubans, who are largely responsible for U.S. policy toward Cuba, have not wanted to hear about any initiatives that might help the Cuban economy. The arguments one hears in Miami against ending the embargo center on two concerns: that every extra dollar Castro takes in will be used first by the army and the Ministry of the Interior, which manage the repressive system, and that the effect will be to extend the life of the regime. Another point often made is that Canadians have been traveling to Cuba, trading and dealing with Castro for nearly forty years, and after all that, they haven't extracted one concession from Castro when it comes to liberalizing his regime. Why expect Castro to act differently after an opening by the Americans? Both are good points, but I would suggest that the dollars on the street from the Canadians and Europeans have changed Cuba. Self-employed workers think differently, act differently, live better than socialist workers, and pay little heed to the socialist government. What is needed is a critical mass of self-employed workers, and an influx of American dollars will surely increase their numbers. Also, what can be lost by trying a new approach? If something doesn't work for forty years, you try something else. Castro now holds the longevity crown for a living totalitarian head of state.

In any case, Cuban exile attitudes seem to be changing, so the votes offered to politicians who support hard-line views are no longer guaranteed. The Pope's visit to Cuba seems to have created a more brotherly tone in the dynamics between the Cubans here and the Cubans there. Even before the Pope's visit, attitudes had been changing. The December 6, 1997, issue of the *New York Times* reported that a poll of Cuban exiles taken by Florida International University every two years is clearly showing a shift toward a less confrontational and more pragmatic attitude on the part of the exiles when it comes to dealing with Castro. The June 1997 poll shows that 48 percent of Cuban Americans favor negotiations with the Cuban Government, compared with 36 percent in a similar poll in 1991.

On my last day in Havana I got up early and went up to the roof of my apartment building. I had already taken some pictures up there, but I wanted to make sure I had some good panoramic views of Havana. I took some pictures, put the camera down, and took some time to take in the view. As I looked east toward El Morro and the Old City, north toward the top of G Street, and west toward Miramar, I saw a skyline identical to the one I remembered from the fifties. There were two notable additions to the old skyline, two new large buildings, both very bad investments in the plant of the city. One was a tall and massive Ministry of Defense headquarters built close to the Malecón, where military officers surely have been trained to keep their eyes on the ocean every day, scanning the horizon for invading American ships. The other large new building I could barely detect was the giant Soviet Embassy in Miramar, another very bad bet.

I was thinking about what a social sciences professor at Ohio State told me once, that maybe there are serious problems in Cuba today, but surely the old days must have been worse, rife with poverty, corruption, and huge inequalities, like in the rest of Latin America. I tried to convince him otherwise, but I didn't know how.

I don't doubt that some of what he said was true. There were problems and inequalities, especially in the countryside. But as I looked at the Havana skyline, I thought I could rebut his argument by simply showing him pictures of the skyline I was witnessing. What the pictures show is a city, built during the pre-Castro days, that extends in every direction as far as the eyes can see, with apartment buildings and solid homes built by and for a very large population—a middle class that could afford them. The image of the Old Cuba that Castro has tried to sell to the world, that of a society where a few rich Cubans and Americans owned and controlled everything, while everyone else was oppressed and poor, does not stand up when one looks at the infrastructure of Havana. Who lived in all those hundred and thousands of modern buildings that I could see in every direction? Not the few Cuban rich and American oppressors, but a gigantic middle class, one of the largest in Latin America at the time of the Revolution.

As I stood on the roof I couldn't help thinking how well I remembered the Havana of the fifties, and how I treasured those memories. What first comes to mind is noise—the incredible noise and bustle of the streets: traffic jams everywhere in the narrow streets of Old Havana, drivers honking their horns and trading insults, the racket from jackhammers pounding the pavement, lottery vendors screaming their numbers, men offering *piropos*, stylized compliments, to virtually every female who crossed their path. From my teenage perspective, the *habaneros* I knew in those days all seemed to have an excess of personality, an excess of energy, of enthusiasm and humor. They didn't seem to suffer from a shortage of dreams

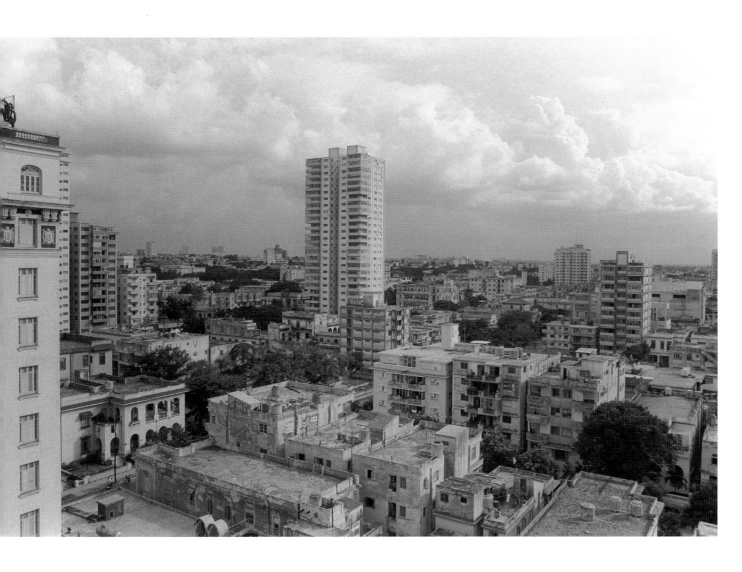

El Vedado looking westward

and schemes to improve their positions and their lives. The end result was that Havana's large middle class was growing larger. That optimism, the belief that anything was possible, is what is completely missing in Cuba today. Now, nothing is possible. There is only darkness at the end of the tunnel.

After my rooftop meditation I quickly went downstairs and finished packing. I said farewell to the lady from whom I had rented the apartment and waited in the lobby for one of the architects who had agreed to take me to the José Martí International Airport. On the ride to the airport I became aware of how eager I was to get on that plane, to get back to familiar territory, to see my wife and children again, to return to a normal life. My fairly uneventful life in the Midwest suddenly seemed very appealing. I'd become accustomed to my simple routines and my small pleasures, to the rule of law, to living in a highly developed and ordered country. At the same time, I was thinking, I could live in Cuba again. Just looking at the deep blue of the ocean and feeling the sea breeze on my face on the rooftop of my apartment building was an intense pleasure.

Cuba, the physical place, just felt right to me. My senses told me that's where I belong.

The architect dropped me off by the main gate and went on to park. As I walked toward the gate, I suddenly froze. Over the main entrance, a very large electronic sign displayed this message:

Flight #12457
A Mendoza
Report Immediately to Gate #4

A Mendoza. Antonio Mendoza. That was me. How many A Mendozas could there be? Report Immediately to Gate 4. Was Gate 4 where the secret police had their offices? My heart immediately started pounding. Did somebody I had talked to report me? Was I going to be arrested just as I stepped onto the plane? I quickly decided I wasn't going in. I'd wait on the curb for the architect and explain the problem and get his opinion. What could it be? I thought of the many Cubans I had talked to, and to whom I had expressed my various antigovernment sentiments; maybe they were all agents of the Cuban regime and had tracked me all along. I thought of the

suggestion I had made to the taxi driver, to create a traffic jam in El Malecón to protest the tax increase. Maybe that driver was an agent and I was being accused of counterrevolutionary activities. Counterrevolutionary activities in Cuba can land you in jail for thirty years.

The architect showed up and I nervously explained my problem. He looked at the sign and thought for a few seconds. Then he smiled and said: "That sign just means that the flight to Mendoza, the city in Argentina, is leaving on Gate 4."

I quickly looked at my ticket. My flight number was a different number. He was right. "A" means "to" in Spanish. I exhaled a long and loud sigh of relief.

I bid farewell to the architect. I went in and bought my allotted three bottles of Bacardí rum, ate an overpriced snack, and boarded the plane. Shortly after takeoff I looked down from my window and watched as we crossed over the Cuban coastline; such a dramatic meeting of the blue ocean, the thin white line of the Santa María del Mar beach, and the green fields beyond. I pressed my face against the window and kept my eyes on that coastline as long as I could, wondering if I would ever see it again. I was sure that I was going to write something about my trip to Cuba and that whatever I wrote was not going to please the Cuban government. I would probably be barred from returning to Cuba again, like other journalists who have written negative articles.

Nevertheless, I'd like to go back. I'm hoping that in my lifetime I'll be faced with a decision between returning to Cuba or staying in the United States. The joke one hears in Havana, that socialism is the economic system between capitalism and capitalism, seems destined to become reality. Someday Castro will die and socialism will wither away. I would guess that many exiled Cubans will return to Cuba, but many will stay in the United States. I would like to do both. I have a fantasy: I'll buy a summer place by the sea in one of those little towns I started to visit before I fell ill. As soon as classes end in June, Carmen (who's also a teacher) and I, our two children, and our two cats will be at the Columbus airport, all very happy to be headed for Cuba for our three-month summer vacation.

EPILOGUE

*I*T'S BEEN TWO YEARS SINCE MY TRIP TO Cuba, and from the many news accounts I've read, little has changed. The economy continues not to function, the lucky Cubans with access to dollars are the only Cubans eating three meals a day, dissidents continue to get arrested, Fidel continues to end his speeches with "Socialism or Death," and the promise he made to the Pope, to allow a greater role for the Church in Cuban society, was a false one.

*Dark clouds forming over royal palms
in Granma Province*